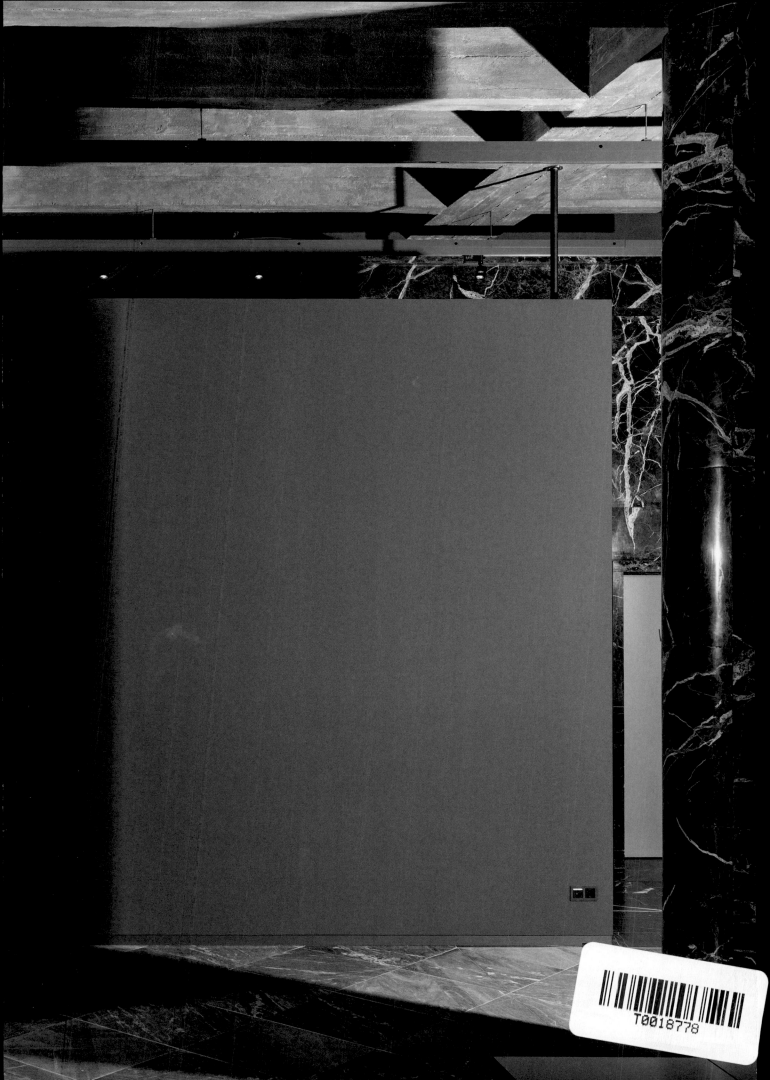

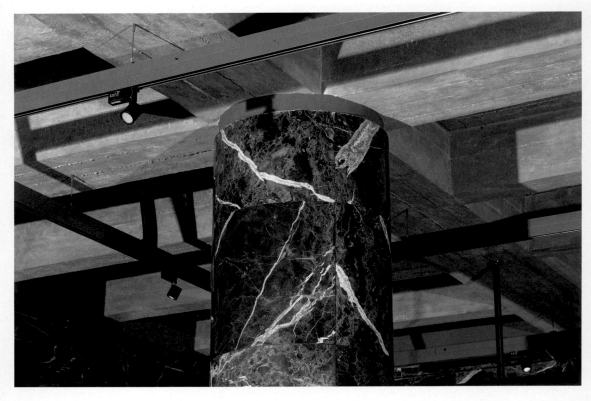

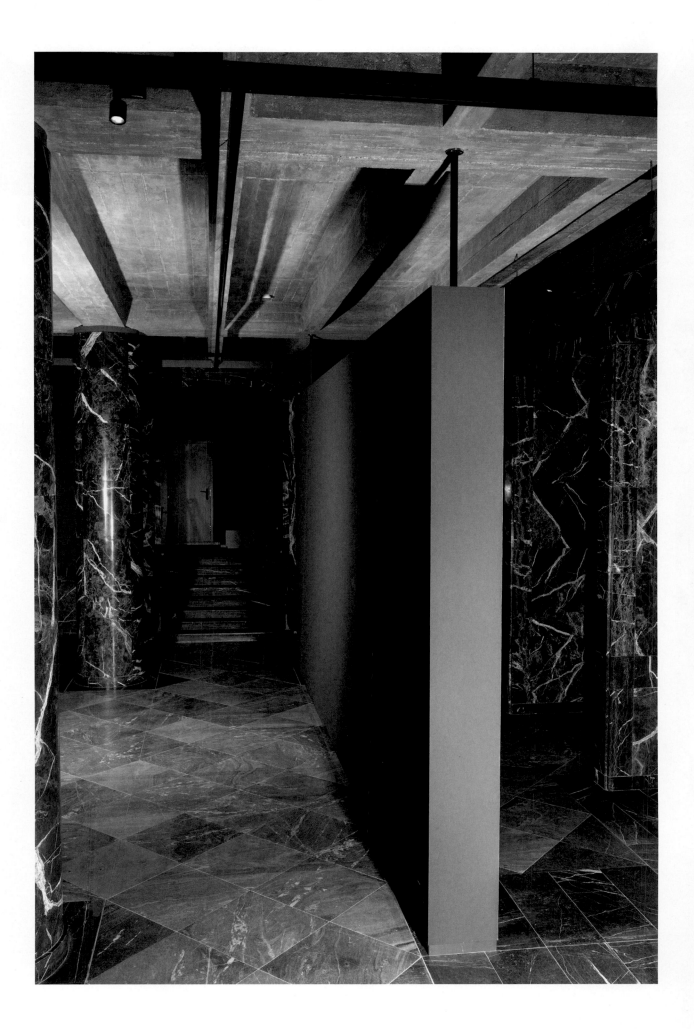

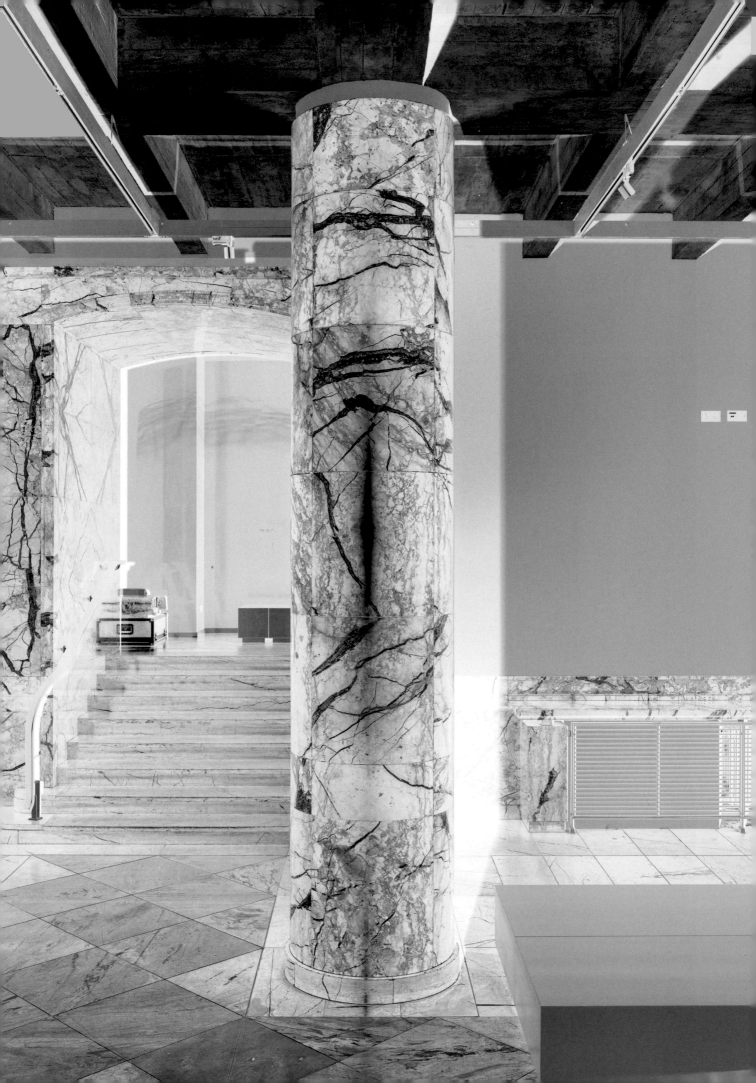

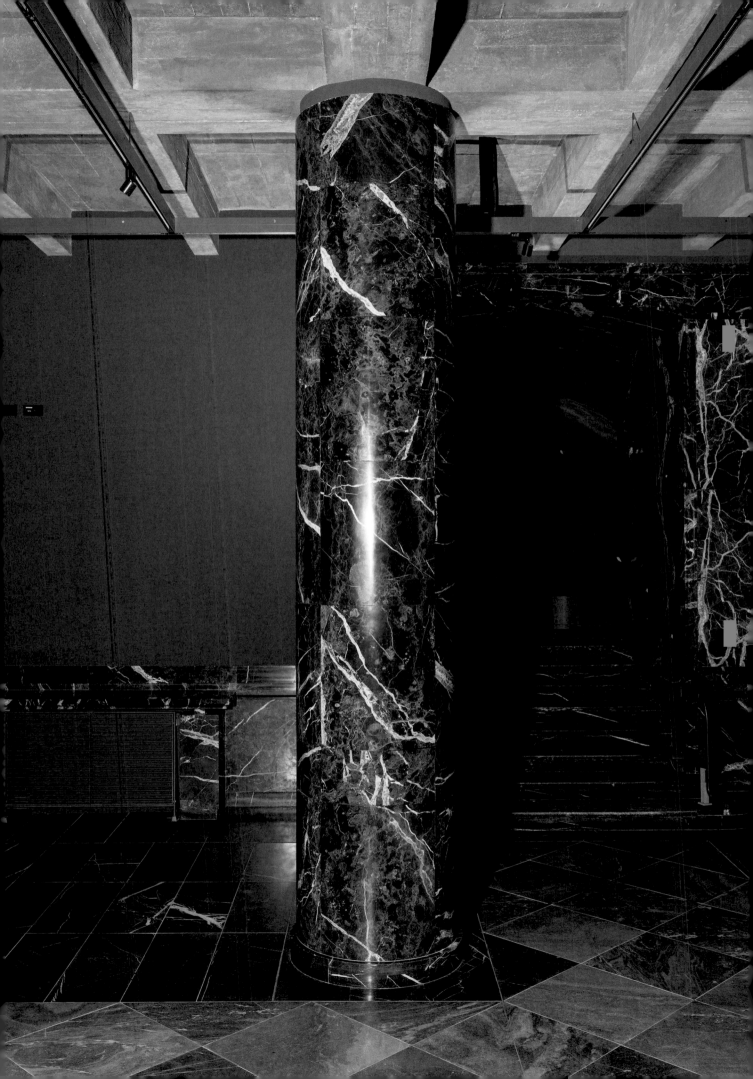

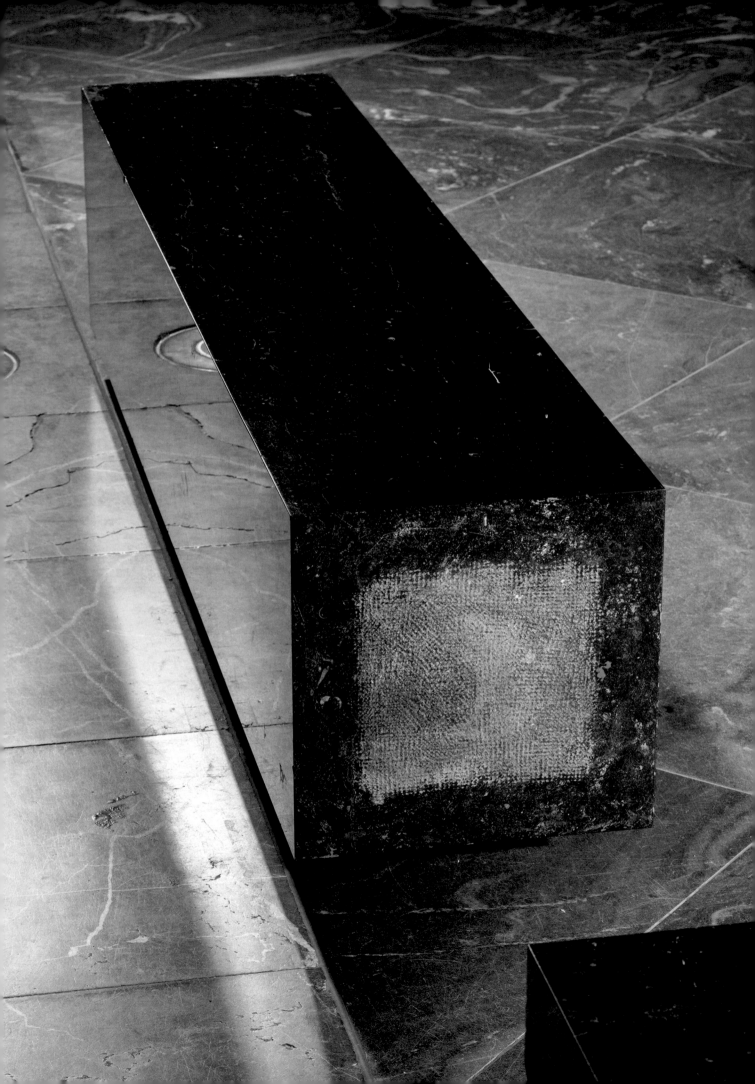

Cover, pp. 1–8:
Daniel Poller, *Kranker Marmor*, 2022

Daniel Poller is a Berlin-based artist. In his photographic
practice, he reflects on history's modifiability, decon-
structing its narratives and producing new ones instead.
His work has been exhibited widely and is part of several
public collections. His recent photo book *Frankfurter
Kopien*, published by Spector Books in 2022, deals with the
reconstruction of the New-Old-Town of Frankfurt am Main.

Dennis Brzek and Junia Thiede
In Medias Res—Status Report(s) between a Present
and Many Pasts

Dennis Brzek und Junia Thiede
In Medias Res – Zustandsaufnahmen zwischen einer
Gegenwart und vielen Vergangenheiten

In its video work *Corpse Cleaner*,[1] the research and film collective 13BC quotes the diary of German philosopher Günther Anders, who lived through the Second World War in exile on the United States' West Coast. After returning to his birthplace of Breslau, he noted the silence of the buildings and residential streets that had survived the air raids, writing that he literally felt mocked by their intactness. In Germany, the immediate postwar debate revolved less around the architecture that withstood the terrors of the war than around what had disappeared. Numerous urban projects intended to close this architectural gap and cover up the wound that had been torn open by the Second World War and the necessary victory over National Socialist tyranny. For Anders and others who had fled National Socialism, however, it was precisely these remaining buildings that figured as a recurrent point of debate after the war. Beyond those buildings that entered the post-1945 era relatively unscathed, especially contested were those that directly originated with the government's war-mongering and ideological apparatus, which was responsible for the widespread destruction of Europe.

One of the most prominent examples is today's Haus der Kunst in Munich, an art museum designed by architect Paul Ludwig Troost and pompously opened in 1937 under the name Haus der Deutschen Kunst (House of German Art) to serve as the first architectural showcase project of Nazi propaganda. During the Nazi era, the building was an early culmination of the Nazi's nationalist cultural politics and the chief means through which to demonstrate their racially motivated conception of art. Like so many other Nazi buildings—built for cultural, military, and administrative uses—the undamaged Haus der Deutschen Kunst was commandeered and repurposed by the victorious powers, motivated by pragmatic concerns. Stripped of their emblems, these buildings' violent histories were overwritten with new functions in the postwar years. To this day, the question of how to properly contend with the Haus der Kunst as a "materialized product ... of racist ideology and propaganda" remains an unresolved topic within social and political debates—with any clear consensus appearing unattainable for the time being.[2]

The former Luftgaukommando III in Berlin-Dahlem—which was also built by the Nazi regime and whose 5.6-hectare site has remained virtually unchanged since its inauguration in 1938—is likewise contextualized by discussions on remembrance and post-regime use. The complex, whose center building today houses Fluentum's exhibition space, shares a similar fate to the Haus der Kunst: both buildings were covered with camouflage nets in the final moments of the war to protect it from air raids and to thus keep it operational for the future the Nazis envisioned: National Socialism's victory in Europe and around the world. Instead, the building would serve the Nazi's victorious enemies after the end of the war, when it was rededicated as the US Army's Berlin headquarters until the mid-1990s. Like many other buildings, the former Luftgaukommando III "suffered the misfortune... of having survived the air raids unscathed," to quote Okwui Enwezor's

In ihrer Videoarbeit *Corpse Cleaner*[1] zitiert das Recherche- und Filmkollektiv 13BC aus dem Tagebuch des Philosophen Günther Anders, der die Jahre des Zweiten Weltkriegs im Exil an der US-amerikanischen Westküste verbrachte. Nach der Rückkehr in seinen Geburtsort Breslau notiert er den stummen Anblick der Gebäude, die die Bombenangriffe der Nationalsozialisten überlebt hatten und schreibt, dass er sich von ihrer Unversehrtheit förmlich verhöhnt fühlt. Im Täterland Deutschland dreht sich die Debatte in der unmittelbaren Nachkriegszeit erst einmal weniger um das architektonische Erbe, als vielmehr um sein Verschwinden. In zahlreichen Projekten sollte die bauliche Lücke geschlossen und die klaffende Wunde der Vergangenheit überblendet werden, die der Zweite Weltkrieg und mit ihm der notwendige Sieg über die nationalsozialistische Tyrannei riss. Doch gerade das, was stehen blieb, wurde für die, die wie Anders vor dem Nationalsozialismus flüchteten, zum immerwährenden Streitpunkt persönlicher und gesamtgesellschaftlicher Debatten – Bauten, die nicht nur die Zeit nach 1945 mehr oder weniger unversehrt betraten, sondern unmittelbar jenes kriegstreiberischen Regierungs- und Ideologieapparats entstammten, der zur weitgehenden Zerstörung Europas führte.

Eines der prominentesten Beispiele bildet das heutige Haus der Kunst in München, ein vom Architekten Paul Ludwig Troost entworfenes und 1937 unter dem Namen Haus der Deutschen Kunst als erstes architektonisches Vorzeigeprojekt der NS-Propaganda pompös eröffnetes Ausstellungshaus. Während der NS-Zeit bildete das Gebäude einen zentralen Kulminationspunkt zur Demonstration nationalistischer Kulturpolitik und eines rassistisch motivierten Kunstbegriffs. Wie so viele andere NS-Bauten für Kultur, Militär und Verwaltung wurde das vollkommen unbeschädigt gebliebene Haus der Deutschen Kunst von den Siegermächten aus pragmatischen Gründen übernommen und, von seinen offensichtlichen Hoheitszeichen entledigt, in den Nachkriegsjahren mit neuen Funktionen überschrieben. Bis heute führt die physische Präsenz dieses Gebäudes als „materialisierte[s] Produkt [...] rassistischer Ideologie und Propaganda"[2] und den hieraus resultierenden Fragen zum heutigen Umgang immer wieder zu drängenden gesellschaftlichen wie (stadt-)politischen Streitgesprächen, innerhalb derer eine Einigung bis auf Weiteres unmöglich erscheint.

Als Funktionsbau des NS-Regimes, dessen äußere Gestalt auf dem 5,6 Hektar großen Areal seit der Einweihung 1938 quasi unverändert blieb, reiht sich auch das ehemalige Luftgaukommando III in Berlin-Dahlem in den Kontext dieser Erinnerungs- und Nachnutzungsdebatten ein. Der Komplex, in dessen zentralem Mittelgebäude heute die Ausstellungsräume von Fluentum angesiedelt sind, teilt dabei ein ganz ähnliches Schicksal wie das Haus der Kunst: Auch das Luftgaukommando III wurde in den letzten Momenten des Kriegs mit Tarnnetzen versehen, um es vor Luftangriffen zu schützen und damit für die spekulative Zukunft nach einem Sieg des Nationalsozialismus in Europa und weltweit einsatzfähig zu halten. Vielmehr diente das Gebäude nach Kriegsende jedoch

contribution to the debate surrounding the renovation of the Haus der Kunst.[3] The end of the Luftgaukommando's political usage came in 1994 when it was handed over to a reunited Germany. Though the complex provided a sober reflection on the violent bureaucratic Nazi apparatus in light of the upcoming twenty-first century, it also represented a deeply ambivalent monument, untouched by the decades of turbulent reappraisal of National Socialist crimes in Germany. As a vacant colossus, the complex, like so many blind spots in postreunification Berlin, led an uneasy existence for a long time. Following vivid public discussions about how best to use the space, the numerous buildings with their seemingly endless office corridors were finally sold and developed into individual housing units. Despite now being in its third iteration of usage, the complex as an artifact of history still allows for the past to be accessed, thus requiring us to resist forgetting and letting it slip away into an untroubled everyday existence.

In discussions on dealing with Nazi architecture, architectural historian and founder of the Munich Documentation Centre for the History of National Socialism Winfried Nerdinger implores us not to lose sight of the motives behind the construction as well as the building's original function.[4] In other words: a differentiated examination of history can only take place around the building itself. *In Medias Res #2: Architecture in Motion* aims to address precisely this point. The second issue of the publication series focuses on architecture in a variety of ways, as well as on the material culture inscribed in the building, tracing the visual markers and imprints of use from the beginning of construction to the present day.

A foundation for this is provided by the essay "Ideology and Architecture of the Luftgaukommando III—A Survey" by Petra Kind, which draws on her many years of work documenting the building complex, in the process outlining the deliberate ideological concerns that shaped the architecture from design to implementation. In 2010, Kind took on the task of documenting the history of the site for the real estate companies Terraplan and Prinz von Preussen Grundbesitz AG as a freelance architectural historian—the first individual to conduct intensive research. While her formal inventory is a strictly determined documentation of the historical architecture, its point of departure of looking from the present at a building that went through several contradictory manifestations destabilizes notions of complete coherency.

In his extensive essay "Dead People and Taboos—On Architectures from the Era of National Socialism and their Conversion Decorum," Stephan Trüby, professor of architectural theory at the University of Stuttgart, problematizes the tensions discussed above with regard to present-day debates on the Nazi's architectural legacy. Through a typological analysis of various buildings from the Nazi era, he highlights the standard formulas and discursive rules established in postwar Germany that governed the subsequent utilization of the regime's architecture. Quoted debates from both academic and media spheres elucidate the continuing relevance, explosiveness, and emotionality of the discussions that have surrounded the repurposing of National Socialist architecture.

The inherent ambivalence of reappraisal and the Fluentum architecture's palimpsest-like blending of times and narra-

den tatsächlichen Siegermächten und wurde fortan bis Mitte der 1990er Jahre als US-amerikanisches Hauptquartier umgewidmet. So wie viele andere Bauten erleidet auch das ehemalige Luftgaukommando III „das Pech [...], die Luftangriffe unversehrt überstanden zu haben", um Okwui Enwezors Beitrag aus der Debatte um die Renovierung des Haus der Kunst zu zitieren.[3] Das Ende der politischen Nutzung des Luftgaukommandos, das 1994 in ein wiedervereintes Deutschland entlassen wurde und mit einem Fuß im anstehenden 21. Jahrhundert ein nüchternes Abbild des gewalttätigen bürokratischen NS-Apparats abgab, bedeutete auch, dass dieses künftig immer ein zutiefst ambivalentes Denkmal darstellen würde, unberührt von Jahrzehnten turbulenter Aufarbeitung nationalsozialistischer Verbrechen in der Bundesrepublik. Als leerstehender Koloss fristete der Komplex wie so viele Blindstellen im Berlin der Nachwendezeit lange eine unbehagliche Existenz. Nach bunten Diskussionen in der Öffentlichkeit über potenzielle Nutzungsstrategien wurden die vielzähligen Gebäude mit ihren schier endlos scheinenden Bürofluren schlussendlich verkauft und als Eigenheimprojekt privatisiert. Doch trotz dieser dritten, mehrheitlich dem Auge der Allgemeinheit verschlossenen Nutzung erlaubt der Komplex weiterhin als Fossil der Geschichte Vergangenheit zu eröffnen, und erfordert dabei, dagegen anzukämpfen, ihn als friedlich Schlafenden in den Alltag hinein zu vergessen.

In den Diskussionen zum Umgang mit NS-Architektur plädiert der Architekturhistoriker und Gründer des NS-Dokumentationszentrum München Winfried Nerdinger, die Beweggründe zur Erbauung sowie die ursprüngliche Funktion eines Gebäudes nicht aus den Augen zu verlieren.[4] Mit anderen Worten: eine differenzierte Auseinandersetzung mit der Geschichte kann nur am Gebäude selbst stattfinden. Mit *In Medias Res #2: Architecture in Motion* soll genau an diesem Punkt angesetzt werden. Die zweite Ausgabe der Publikationsreihe rückt auf vielfältige Weise die Architektur sowie die in das Gebäude eingeschriebene materielle Kultur in den Fokus, und zeichnet visuelle Marker und Nutzungsspuren vom Baubeginn bis zur Jetztzeit nach.

Eine Grundlage dafür liefert der Essay *Ideologie und Architektur des Luftgaukommandos III – Eine Bestandsaufnahme* von Petra Kind, der ihre langjährige Arbeit an der Erfassung des Gebäudekomplexes versammelt und dabei die gezielten ideologischen Setzungen in der ästhetischen Ausformung der Architektur vom Entwurf bis zur Umsetzung skizziert. Kind übernahm 2010 als freischaffende Architekturhistorikerin die bauhistorische Dokumentation für die Immobilienunternehmen Terraplan und Prinz von Preussen Grundbesitz AG und recherchierte als Erste intensiv zur Geschichte des Baus. Ihre zum Teil formale Bestandsaufnahme spricht von einem wissenschaftlichen Status quo der historischen Architektur, blickt jedoch zwangsläufig aus der Gegenwart auf einen Bau, der widersprüchliche Designationen durchlief und dabei in seinem Fundament nur vermeintlich stabil blieb.

Dass die eingangs skizzierten Spannungen in Bezug auf den heutigen Umgang mit dem NS-Erbe sich gerade am Beispiel der Architektur auf sehr unterschiedliche Weise gestalten, problematisiert Stephan Trüby, Professor für Architekturtheorie an der Universität Stuttgart, in seinem umfangreichen Essay *Tote und Tabus – Über Architekturen aus der Zeit*

tives are underscored in the conversation with the architects Matthias Sauerbruch, one half of the architectural firm Sauerbruch Hutton, and David Wegener, who has worked for Sauerbruch Hutton since 2001 and has been a partner since 2020. Responsible for the refitting of the historical architecture that took place between 2017 and 2019, they talk about the challenges and strategies involved in dialogically engaging with historical constructions of meaning.

Working with visual knowledge and built ideologies necessitates returning again and again to the tools provided by artistic knowledge production. These strategies are central to the publication series *In Medias Res* and its mission to reassess the past. History, in its most classical and, according to modernity, objective form, achieves its aim through academic methods and formal rules. In his artistic contribution, Julian Irlinger exposes the individual building blocks of historical analysis by negating that which might initially appear to be central: the main body of text. Deliberately omitting clear-cut legibility, Irlinger shifts the focus to a specific feature of the academic toolbox—the footnotes—and reveals that even history carved in stone, upon closer examination, turns out to be above all a fragile and highly fragmentary construct made up of a wide variety of voices, references, and layers that disintegrate over time.

For the production of her new video work *UNICA*, first exhibited at Fluentum in spring 2022, Anja Kirschner explored the intersection of material and historical layers by looking at Teufelsberg in Berlin. Kirschner sees Teufelsberg, an artificially created landscape heaped together on top of ruins of the Second World War, as a sedimentation of the past. The photographs reproduced here document fragments and puzzle pieces of a history whose aftermath is still present today. Their material configuration as literally melted relics of violence, however, does not allow for clear reference to a past elaborated through the methods of scholarship. Kirschner interprets her findings from Teufelsberg as responses to a type of historiography that succumbs to the arrogance of its rational methods.

In Medias Res #2: Architecture in Motion is complemented by visual material that critically addresses the question of the image: collages, arranged by graphic design studio HIT, combine numerous archival fragments and photographs into an incomplete history of artworks, design elements, and other relics of culture in and around Luftgaukommando III and later the US headquarters. In focusing on these mostly minor details, the collages aim not only to convey how the site can be embedded in an art history of (West) Berlin, but also how the archive, with its absences and presences, can become a guide for working curatorially in the present. Moreover, the complex's formal vocabulary of fixed perspectives and harmonious central axes are counterposed by Daniel Poller's contribution, which forms the issue's introduction. Through a series of photographs, Poller creates a visual narrative that hones in on the institutional framework of Fluentum and how it figures as a response to the intertwining of architecture and history.

The second issue's contributions are unified by their shared confrontation of architectural legacy with a critical toolbox: removal and demolition, concealing and uncovering,

des Nationalsozialismus und ihr Umnutzungsdecorum. Anhand einer schematischen Bestimmung verschiedener Gebäudetypen aus der NS-Zeit stellt er erstmals die sich im Nachkriegsdeutschland diskursiv herausbildenden Umgangsformeln in Bezug auf die Nachnutzung von NS-Architekturen heraus. Durch die Einbindung zeitgenössischer Stimmen aus dem akademischen wie medialen Raum wird dabei mitunter auch die Aktualität, Brisanz und Emotionalität deutlich, die die Debatten rund um Umnutzungsfragen zu nationalsozialistischer Architektur nach wie vor innehaben.

Gerade jene Ambivalenz in der Aufarbeitung, die palimpsestartige Überlagerung von Zeiten und Narrativen, die sich in dem Gebäude vereinen, wird im Gespräch mit den Architekten Matthias Sauerbruch, eine Hälfte des Architekturbüros Sauerbruch Hutton, und David Wegener, seit 2001 für Sauerbruch Hutton tätig und seit 2020 Partner, deutlich. Zwischen 2017 und 2019 mit der Umgestaltung der Räume, die heute Fluentum beherbergen, betraut, berichten die Architekten von den Herausforderungen und Strategien in der dialogischen Auseinandersetzung mit historischen (Bedeutungs-) Konstruktionen.

Die Arbeit mit visuellem Wissen und gebauten Ideologien erfordert auf besondere Weise, immer wieder auf die Werkzeuge künstlerischen Wissens zurückzugreifen, die in der Publikationsreihe *In Medias Res* und ihrer Aufgabe, Vergangenes aufzuarbeiten, eine zentrale Stellung einnehmen. Geschichte, in ihrem klassischsten sowie, der Moderne zufolge, objektivsten Gewand, findet im methodischen Vorgehen sowie im Erscheinungsbild des wissenschaftlichen Texts ihre Entsprechung. In seinem künstlerischen Beitrag widmet sich Julian Irlinger auf formaler Ebene einzelnen Elementen dieser Art historischer Forschung, indem ein Text buchstäblich in seine Einzelteile zerlegt wird. Durch die gezielte Auslassung des Hauptnarrativs verschiebt Irlinger den Fokus auf das Beiwerk – die Fußnoten – und legt so offen, dass sich selbst in Stein gemeißelte Geschichte bei genauerer Betrachtung vor allen Dingen als ein fragiles und höchst fragmentarisches Konstrukt aus unterschiedlichsten Stimmen, Referenzen und Zeit zersetzenden Ebenen ausweist.

Anlässlich der Produktion ihrer neuen Videoarbeit *UNICA*, die im Frühjahr 2022 bei Fluentum präsentiert wurde, setzte sich Anja Kirschner anhand des Teufelsbergs in Berlin mit der operativen Überschneidung materieller und historischer Schichten auseinander. Kirschner liest den Teufelsberg, eine künstlich angelegte Landschaft, aufgeschüttet auf Ruinen des Zweiten Weltkriegs, als Sedimentierung von Vergangenheit. Die hier abgedruckten Fotografien dokumentieren Fragmente und Puzzleteile einer Geschichte, deren Nachwirken bis heute präsent ist. Ihre materielle Konfiguration als verschmolzene Relikte von Gewalt erlaubt es dabei jedoch nicht, klare Verweise auf eine mit den Methoden der Wissenschaftlichkeit erarbeiteten Vergangenheit zu ziehen. Kirschner liest die Funde auf dem Teufelsberg als Beispiele für eine Perspektive auf Geschichtsschreibung, die dem Hochmut ihrer rationalen Methoden erliegt.

Ergänzt wird *In Medias Res #2: Architecture in Motion* durch visuelles Material, das sich der Frage nach dem Abbild zuwendet: In zahlreichen archivarischen Fragmenten und Fotografien, die das Grafikstudio HIT zu Collagen arrangierte,

rearranging and reoccupying. All of these are strategies that at once create and negate forms. In the process, it becomes apparent that supposedly intact and static architecture, as a monumental representation of the visible, carries within it the remains and traces of the invisible and thus ultimately motion—both of which are indispensable for any reappraisal of history.

1 The work from 2019 was part of the group exhibition *Time Without End* (September 15–December 11, 2021), inaugurating the Fluentum program series *In Medias Res: Media, (Still) Moving*.
2 Winfried Nerdinger, "Sind Steine unschuldig? Zum Umgang mit NS-Architektur" (lecture, NS-Dokumentationszentrum, Munich, March 1, 2017) [translated by the authors].
3 Okwui Enwezor, "Kritiker äußern gedankenlose Bemerkungen," *Süddeutsche Zeitung*, January 28, 2017, https://www.sueddeutsche.de/kultur/diskussion-um-haus-der-kunst-okwui-enwezor-kritiker-aeussern-gedankenlose-bemerkungen-bemerkungen-1.3352118 [translated by the authors].
4 See note 2.

wird eine unabgeschlossene Geschichte kunsthandwerklicher und anderweitig ästhetischer Setzungen im und um das Luftgaukommando III und spätere US-Hauptquartier entworfen. In der Fokussierung auf solche Details soll nicht nur nähergebracht werden, wie sich der Ort, nun ein Schauplatz für zeitgenössische Kunst, in eine Kunstgeschichte (West-)Berlins einbetten lässt, sondern auch, wie das Archiv zwischen Abwesenheit und Präsenz eine Anleitung für die Arbeit im Heute stiften kann. Der im Bau manifestierten Formensprache aus fixierten Perspektiven und harmonischen Mittelachsen setzen zudem die Fotografien von Daniel Poller, die den Einstieg der Ausgabe bilden, eine visuelle Erzählung entgegen, die den institutionellen Rahmen Fluentums als Replik auf die Verquickung von Architektur und Geschichte verdeutlicht.

Sämtliche Beiträge der zweiten Ausgabe eint nicht zuletzt die Beschäftigung mit praktischen Herangehensweisen an ein architektonisches Erbe: dem Entfernen und Abtragen, dem Verdecken und Aufdecken, dem Umarrangieren und Neubesetzen. Im Herausarbeiten dieser formgebenden wie -negierenden Methoden zeigt sich, dass vermeintlich unversehrte Architekturen als monumentale Repräsentation des Sichtbaren immer auch die Reste und Spuren des Unsichtbaren und damit letztlich der Bewegung in sich tragen, die zur Annäherung an die Aufarbeitung von Geschichte jedoch unerlässlich sind.

1 Die Arbeit aus dem Jahr 2019 war Teil der Gruppenausstellung *Time Without End* (15. September – 11. Dezember 2021), mit der Fluentum die Programmreihe *In Medias Res: Media, (Still) Moving* eröffnete.
2 Winfried Nerdinger, *Sind Steine unschludig? Zum Umgang mit NS-Architektur*, Vortrag im NS-Dokumentationszentrum München, 1. März 2017.
3 Okwui Enwezor, „Kritiker äußern gedankenlose Bemerkungen", in: *Süddeutsche Zeitung* [28.01.2017], URL: https://www.sueddeutsche.de/kultur/diskussion-um-haus-der-kunst-okwui-enwezor-kritiker-aeussern-gedankenlose-bemerkungen-1.3352118 (letzter Zugriff: 28.06.2022).
4 Nerdinger (wie Anm. 2).

Dennis Brzek is Guest Curator at Fluentum. Junia Thiede is Fluentum's Head of Exhibitions and Programs. Together, they are the curators of the project series *In Medias Res: Media, (Still) Moving*.

Petra Kind
Ideology and Architecture of the Luftgaukommando III—
A Survey

The architectural program of the Luftgaukommando III in Berlin-Dahlem, constructed between 1936 and 1938, embodied the "new building spirit" of National Socialist Germany in exemplary fashion—according to the emphatic wording of the Building Administration's Zentralblatt der Bauverwaltung, published a few years after its completion.[1]

Housing the Luftwaffe's headquarters, the building complex was granted highest priority in the Reichswehr's rearmament and represented one of many components of the Nazi state's orchestration of power, which was already in full swing just a few years after the takeover in 1933. As an administrative building, the Luftgaukommando III is archetypal among large-scale projects constructed during the prestige-driven early phase of the National Socialist regime, especially in cities like Nuremberg and Berlin both of which carried a strong ideological significance. In addition to the urgent functional need to provide the command staff's administrative management, at that time still known as Luftkreiskommando II, with their own premises, the overarching political (construction) task was to adequately manifest the National Socialist worldview. The enormous Luftwaffe construction program was directly overseen by the Ministry of Aviation and its commander-in-chief Hermann Göring. A specially established central construction administration, located directly in the ministry, coordinated and controlled all Luftwaffe construction projects. The largest German administrative building, the Ministry of Aviation, which had 2,000 offices, was built in Berlin in 1935—just one year before construction of the Luftgaukommando was both begun and completed in 1936. Construction of Tempelhof Airport, which at the time was the world's largest airport building, also began in 1936. Both the Ministry of Aviation and Tempelhof Airport were designed by the Luftwaffe's in-house architect, Ernst Sagebiel.

In late summer 1935, a competition for the Luftkreiskommando II, later renamed Luftgaukommando III, was held between the architects Hans Poelzig, who had already realized Berlin's Haus des Rundfunks; Heinrich Straumer, who designed the Berlin Radio Tower; and Fritz Fuß. The only surviving documents are Poelzig's drafts and two documents from Fuß' portfolio. In Poelzig's case, concessions to National Socialist dogma can be observed, but the complex did not achieve enough of a sense of dramatic presence to fulfill the National Socialists' desires. Fritz Fuß won the competition with a design that was firmly inspired by the Dresden Luftgaukommando, which he was familiar with through his teacher Wilhelm Kreis and for which construction had already begun in 1935. In a grand gesture of right-angled monumentality, the complex was planned to occupy the idyllic pine forest on about eight hectares between the Dahlem villas, in an east-west orientation at the corner of Saargemünder Straße and Kronprinzenallee.

After only nineteen months, the entire complex, which stretches to a length of around 345 meters, was completed. The building ensemble consisted of areas for the administration, an elaborate venue for special occasions, as well as a barracks and the Luftkriegsgericht (air force court), both ad-

Petra Kind
Ideologie und Architektur des Luftgaukommandos III –
Eine Bestandsaufnahme

Das architektonische Programm des Luftgaukommandos III in Berlin-Dahlem, erbaut zwischen 1936 und 1938, verkörpert – so die eindringliche Formulierung des wenige Jahre nach der Fertigstellung erschienenen Zentralblatts der Bauverwaltung – beispielhaft die „neue Baugesinnung"[1] des nationalsozialistischen Deutschlands.

Als Kommandostelle der Luftwaffe genoss der Gebäudekomplex bei der Aufrüstung der Reichswehr höchste Priorität und bildete einen von vielen Bausteinen in der herrschaftlichen Machtinszenierung des NS-Staats, die bereits wenige Jahre nach der Machtergreifung 1933 in vollem Gange war. Gerade in seiner Funktion als Verwaltungsbau reiht sich das Luftgaukommando III in den Kanon der ersten nationalsozialistischen Großprojekte ein, die in der nach Prestige heischenden Aufbauphase vor allem in den auf besondere Weise ideologisch verankerten Reichsstädten Nürnberg und Berlin errichtet wurden. Neben dem dringend notwendig gewordenen funktionalen Bedürfnis, die administrative Leitung des damals noch unter dem Namen Luftkreiskommando II gefassten Führungsstabs in eigenen Räumlichkeiten unterzubringen, galt die übergeordnete politische (Bau-)Aufgabe, die nationalsozialistische Weltanschauung adäquat zu manifestieren. Gesteuert wurde das enorme Aufbauprogramm der Luftwaffe unmittelbar durch das Reichsluftfahrtministerium und seinem Oberbefehlshaber Hermann Göring. Eine eigens dafür eingerichtete zentrale Bauverwaltung, direkt angesiedelt im Ministerium, koordinierte und kontrollierte alle baulichen Projekte der Luftwaffe. In Berlin wurde 1935 – nur ein Jahr vor dem Beginn der Arbeiten am Luftgaukommando und in rasant kurzer Zeit – bis 1936 das mit 2.000 Büroräumen größte deutsche Verwaltungsgebäude, das Reichsluftfahrtministerium, errichtet. Auch der Bau des Flughafens Tempelhof mit dem damals weltweit größten Flughafengebäude wurde 1936 begonnen. Sowohl das Reichsluftfahrtministerium als auch der Flughafen Tempelhof wurden vom Hausarchitekten der Luftwaffe, Ernst Sagebiel, entworfen.

Für das Luftkreiskommando II, das später in Luftgaukommando III umbenannt wurde, fand im Spätsommer 1935 ein engerer Wettbewerb unter den Architekten Hans Poelzig, der in Berlin bereits das Haus des Rundfunks errichtete, Heinrich Straumer, aus dessen Feder der Berliner Funkturm stammte, und Fritz Fuß statt. Einzig überliefert sind die Entwurfsblätter von Poelzig sowie zwei Dokumente aus Fuß' Entwurfsmappe. Bei Poelzig lassen sich Konzessionen an das nationalsozialistische Dogma erkennen, das erwartete inszenatorische Moment war aber für die Anforderung zu schwach. Fritz Fuß, der durch seinen Lehrer Wilhelm Kreis das Dresdner Luftgaukommando, für das bereits 1935 Baubeginn war, kannte, gewann den Wettbewerb mit einem Entwurf, der sich stark an diesem orientierte. Die Anlage wurde in den idyllischen Kiefernwald, zwischen den Dahlemer Villen, auf rund 8 Hektar in Ost-West-Ausrichtung an der Saargemünder Straße, Ecke Kronprinzenallee in einer großen Geste in rechtwinkliger Monumentalität projektiert.

Nach nur 19 Monaten war die gesamte Anlage mit einer Ausdehnung von rund 345 Metern fertiggestellt. Das Gebäu-

joined to the north. The functional buildings typical for the administration of a command post are grouped symmetrically along an axis with sober, monotonous punched window façades, conspicuously placed architectural accents, and obvious symbols of power, such as towering pillars, eagle sculptures, and swastika reliefs. The buildings have a rectangular layout and are designed as two-story plaster constructions with high-hipped roofs. The main building, comprised of four adjoining wings, was erected through the then-modern method of a reinforced concrete frame. The ceilings and roof were partly built from solid reinforced concrete—the so-called "coffin lid"—while the rooms' walls were lined with bricks. The other buildings, including the two-columned buildings, the *Speiseanstalt* (mess hall), the radio building, and the barracks quarters, are all of solid masonry.

The recurring design elements typical of Wehrmacht buildings of this period, such as round windows, linear incisions in the natural stone or plaster, and rectangular and square enclosures or railings, can also be found on all the buildings. As architectural historian Ulrich Hartung noted in his study of the resonances between architectural forms and ideological requirements, "the monumental buildings of the Third Reich...consisted of massive, geometrically concentrated individual forms, which were self-contained and yet locked into a unifying pattern of order."[2] The motifs of squares, rectangles, circles, lines, and shadow gaps, as well as clear surfaces, repeat and increase hierarchically. Beyond these symbolic purposes, however, the buildings also had to fulfill certain functional requirements. The monotonous façade speaks to the restraint and formality of the work performed in the mostly one- or two-axis offices that laid behind them, which were accessed via central corridors. In keeping with the typical design features for prestigious Luftwaffe buildings of the time, façades were clad with prefabricated ashlars of shelly limestone. Avant-corps, pilaster strips, and cornice bands made of shelly limestone slabs accentuated the elongated façades.

The entrances of the portal buildings were built in the style of stripped classicism and featured high pillar porticos decorated with eagles. The shelly limestone found on all buildings provided the complex with a coherent appearance. Prefabricated ashlars of basalt, limestone, sandstone, granite, and slate on the exterior, and polished limestone and marble on the interior, emphasized sentiments of high value and superiority. Two-tone windows painted white and blue and doors painted gray referenced the buildings' use as an aviation command post. Details such as the two black lampposts on the outside staircase and the balcony grille of the so-called *Führerbalkon* ("Führer's balcony") were set in black iron, partially accentuated with gold.

The main building's central avant-corps, clad in shelly limestone, protrudes outwards via concave curves and is complemented with archaic-looking elements such as the polygonal plinth and the conical door frames, which feature deep shadow gaps. Five narrow, tall French windows rise above the wide Führerbalkon. Above the attic, a 4.5-meter-long bronze eagle spreads its wings. The sculptural ornamentation, which consisted of eagles, meandering friezes, and other emblems deliberately placed at prominent points on the buildings, were the work of the Rhineland sculptor Willy Meller,

Petra Kind is an independent architectural historian in Berlin. Since 2008, she has been compiling expert assessments on listed or historically significant buildings for private and public clients. From 2011 to 2017, she was advisor for the development project The Metropolitan Gardens (formerly Luftgaukommando III), and has also served as the advisor for the renovation of the neighboring US Consulate (formerly Luftkriegsgericht) since 2017.

deensemble unterteilte sich in den Verwaltungs-, Repräsentations- und Kasernenbereich sowie dem nördlich angeschlossenen Luftkriegsgericht. Entlang einer Achse gruppieren sich symmetrisch die für die Verwaltung einer Kommandostelle typischen Funktionsbauten mit nüchternen, monotonen Fensterlochfassaden, pointiert gesetzten architektonischen Akzenten und deutlichen Machtsymbolen, wie hochaufragende Pfeiler, Adlerskulpturen und Hakenkreuzreliefs. Die Gebäude besitzen einen rechteckigen Grundriss und sind als zweigeschossige Putzbauten mit hohen Walmdächern ausgeführt. Das vierflügelige Hauptgebäude wurde in der damals sehr modernen Stahlbeton-Skelettbauweise errichtet. Die Zwischendecken und das Dach wurden zum Teil aus massivem Stahlbeton, dem sogenannten „Sargdeckel", gebaut, Zimmerwände mit Ziegelsteinen ausgemauert. Die anderen Gebäude, wie die beiden Portalbauten, die Speiseanstalt, das Funkgebäude und die Kasernenunterkünfte, sind massive Mauerwerksbauten.

Immer wiederkehrende, für Wehrmachtsbauten dieser Zeit typische Gestaltungselemente, wie Rundfenster, lineare Einschnitte im Naturstein oder im Putz sowie rechteckige und quadratische Einfassungen oder Geländer, finden sich auch hier an allen Gebäuden. Wie der Architekturhistoriker Ulrich Hartung in seiner Untersuchung zur Konvergenz von architektonischen Formen und ideologischen Ansprüchen feststellt, „[bestanden] Monumentalgebäude des Dritten Reiches [...] aus massiven, geometrisch konzentrierten Einzelformen, die in sich geschlossen und doch in ein verbindendes Ordnungsmuster eingespannt waren."[2] Die Motive Quadrat, Rechteck, Kreis, Linien und Schattenfugen sowie klare Flächen, wiederholen sich und sind hierarchisch gesteigert. Neben dem repräsentativen Anspruch musste aber auch die Funktionalität als Dienstgebäude gewährleistet werden. Die monotonen Fensterlochfassaden sprechen für die Zurückhaltung und Formalität der Arbeit in den dahinter befindlichen, meist ein- oder zweiachsigen Büroräume, die durch Mittelflure erschlossen werden. Entsprechend den damaligen typischen Gestaltungsmerkmalen für repräsentative Bauten der Luftwaffe wurden Fassadenbereiche mit vorgefertigten Werksteinen aus Muschelkalkstein verkleidet. Risalite, Lisenen und Gesimsbänder aus Muschelkalksteinplatten akzentuierten die langgestreckten Fassaden.

Die Eingänge der Portalbauten im Stil des vergröberten Klassizismus erhielten hohe, adlergeschmückte Pfeilerportiken. Der an allen Gebäuden vorzufindende Muschelkalkstein gab der Anlage Geschlossenheit. Vorgefertigte Werksteine aus Basaltlava, Kalkstein, Sandstein, Granit und Schiefer im Außenbereich sowie polierte Kalksteine und Marmor im Innenbereich betonten einen hohe Wert und die übergeordnete Zugehörigkeit. Zweifarbige Fenster mit weißen und blauen Lackierungen und Türen in grauem Farbton verwiesen auf die Nutzung der Gebäude als Kommandostelle der Luftfahrt. Details wie die zwei schwarzen Laternenmasten auf der Freitreppe und das Balkongitter des „Führerbalkons" waren in schwarzem Eisen gefasst, teilweise mit Gold akzentuiert.

Der mit Muschelkalkstein verkleidete Mittelrisalit des Hauptgebäudes wird konkav nach vorne geführt und mit archaisch anmutenden Elementen wie dem polygonalen Sockel und die konischen Türrahmungen mit tiefen Schattenfugen ergänzt. Über dem breiten „Führerbalkon" erheben sich

whom Fuß had already collaborated with in Cologne and the surrounding area.

A coherent sense of dramatic presence was achieved through limited yet expressive design means. This can be observed both from a distance when looking at the complex from the west—which is only possible to a limited extent today due to other buildings—and when walking from the guard-houses to the main building. The backdrop-like, staggered arrangement of the individual buildings can be seen particularly well from a distance, via the extension of the inner cul-de-sac. The horizontal and vertical axes, combined with the contrast between light and dark in the building materials, heighten this effect. The architecture's intended exaggerated appearance and its monumentality become clear here for the first time. Within the complex's architectural system, the administrative buildings thus gain a greater symbolic significance in comparison to the rather plain execution of the surrounding components. The architecture's hewing to the dictates of Nazi ideology is made further apparent when one perceives the space by traversing the main square along the pathways from the guardhouse to the main building. The path is informed by a dramaturgy that combines the floor's gradually rising height with the sense of a backdrop: one sees the deepening of the square upon entry from Kronprinzenallee, followed by the guard houses' towering and affecting pillar porticoes, the flanking columned buildings, a slowly ascending pathway that leads to the final square in front of the main building—also known as the cour d'honneur—with its avant-corps and crowning bronze eagle. In the course of this symbolic journey, man as the smallest unit within a great apparatus of power traverses the path from being an individual to a part of a greater whole. Inside the main building, this dramaturgy is informed by a similar corporeal choreography: first by the oppressive foyer, lined with dark limestone, and then by the subsequent high staircase window that draws the viewer in—originally containing stained glass work by artist Alfred Mahlau—before continuing to the bright, symmetrically curved double-flight staircase that leads one upward. Having reached the landing, one is faced with a gallery leading to the hall behind it. Busts of Adolf Hitler and Hermann Göring, made from polished limestone, stood on black plinths in the niches to the right and left of the entrance. It is only now—after having completed the long walk through the oppressive and dark entrance, ascended the stairs that pull one in, and paused for a moment of contemplation—that one enters the large hall. Upon arriving here, one could step onto the wide balcony and look down outside at the demonstration of power manifested through stone. The Luftgaukommando III is an administrative Nazi state Luftwaffe building that demonstrates the meticulousness with which Nazi ideology was embodied within an overarching building program.

1 See *Zentralblatt der Bauverwaltung* (1940): 345.
2 Ulrich Hartung, "Bausteine für Führerkult und Gemeinschaftsglaube," *kunsttexte.de,* no. 3 (2010): 15.

fünf hohe französische Fenster. Über der Attika breitete ein 4,5 Meter langer, flacher Bronzeadler seine Flügel aus. Der plastische Schmuck wie Adler, Mäanderfriese und andere Hoheitszeichen, die gezielt an markanten Punkten der Gebäude angebracht waren, stammen von dem rheinländischen Bildhauer Willy Meller, mit dem Fuß bereits während seiner Aktivitäten in Köln und Umgebung zusammenarbeitete.

Durch wenige, aber ausdrucksstarke Gestaltungsmittel wurde eine kohärente Inszenierung erzielt. Zum einen erschließt sich diese aus der Fernwirkung beim Anblick der Anlage aus westlicher Richtung, der heute durch die Bebauung nur bedingt möglich ist, und zum anderen beim Zurücklegen des Wegs von den Wachhäusern zum Hauptgebäude. Aus der Ferne, in Verlängerung der inneren Stichstraße, erkennt man besonders gut die kulissenhafte Staffelung der einzelnen Gebäude. Die horizontalen und vertikalen Achsen, verbunden mit der Hell-Dunkel-Kontrastierung der Materialien, unterstützen diese Wirkung. Hier werden zum ersten Mal die beabsichtigte architektonische Überhöhung des Erscheinungsbilds der Anlage und ihre Monumentalität deutlich, die den Verwaltungsbau damit gegenüber der eher schlichten Ausführung der umliegenden Gebäudeteile auf eine höhere Stufe im ideologischen System der NS-Bauten hebt. Auch in der Wahrnehmung des Raums, beim Durchschreiten der Platz- und Wegesysteme von den Wachhäusern bis zum Hauptgebäude, wird man diesem Gesamtanspruch gewahr. Der Weg unterliegt einer Dramaturgie, die sich, abgesehen von der sukzessiven Anhebung der Geschosshöhen, ebenfalls kulissenhaft darstellt: die Vertiefung des Platzes beim Zutritt von der Kronprinzenallee, die darauf folgenden, hoch aufragenden und einnehmenden Pfeilerportiken der Wachhäuser, die flankierenden Portalgebäude, die langsam ansteigende Rampe und der finale Platz vor dem Hauptgebäude – auch „Cour d'honneur" genannt – mit Risalit und bekrönendem Bronzeadler. Der Mensch als kleinste Einheit innerhalb des großen Machtapparates durchläuft hier exemplarisch den Weg vom Einzelnen zum Teil des Ganzen.

Im Inneren des Hauptgebäudes wird diese Dramaturgie durch eine vergleichbare korporale Choreographie bestimmt: zuerst durch das bedrückende und mit dunklem Kalkstein ausgekleidete Foyer sowie dem darauf folgenden, Betrachter*innen zu sich ziehenden hohe Treppenhausfenster, das ursprünglich eine farbige Glasschliffarbeit des Lübecker Künstlers Alfred Mahlau enthielt, weitergeführt zur hellen, symmetrisch geschwungenen, nach oben führenden zweiläufigen Treppe. Angelangt auf dem Treppenpodest befand man sich auf einer Galerie, die zum dahinter liegenden Saal führt. In den Nischen vor dem Eingang standen rechts und links auf schwarzen Sockeln die Büsten von Adolf Hitler und Hermann Göring aus poliertem Kalkstein. Erst jetzt, nach dem langen Weg des Aufstiegs, des bedrückenden, dunklen Entrées, des sogartigen Treppenaufstiegs und der Kontemplation, betrat man den großen Saal. Dort angelangt, konnte man auf den breiten Balkon treten und hinabschauen, auf die zu Stein gewordene Machtdemonstration.

Das Luftgaukommando III ist ein Verwaltungsbau der Luftwaffe des NS-Staats, der zeigt in welcher Akribie die NS-Ideologie auf ein übergeordnetes Bauprogramm projiziert wurde.

1 Vgl. *Zentralblatt der Bauverwaltung* 24 (60), Berlin 1940, S. 345.
2 Ulrich Hartung, „Bausteine für Führerkult und Gemeinschaftsglaube", in: *kunsttexte.de*, Nr. 3, 2010, S. 15.

Introduction
Julian Irlinger

Annotations provide a realm for thoughts, comments, evidence, or quotations that, as a desideratum of the statements in a main body of text, satisfy a number of an author's emotional needs: self-critical additions to an observation; orthodox safeguarding of the origins of one's thought; paths of argumentation still open in an enticing way. In Julian Irlinger's contribution to *In Medias Res #2*, endnotes adorn otherwise blank pages, constructing a text that renders the negation of space as its very subject.

The concept of annotations constitutes the formal infrastructure for an engagement with an object that is committed to the premises of academic scholarship. With the help of source information, references, and citations, any historical reappraisal—just as is the case in this publication project—erects something of an architecture of knowledge, piece by piece, reference by reference. Irlinger applies this very method and in the process dissolves its habit of concrete referentiality: The underlying text seems to have vanished, its statements no longer discernible, with only the superscript numbers allowing for the reader's aimless navigation through the blue pages' emptied space. A glance at the endnotes reveals a mosaic of individual details about the history of the Luftgaukommando III, supplemented by references to the changes in building and property laws of the time. These artifacts serve as analogies that shed light on the changes in Germany's political systems during the twentieth century. The endnote as an exhibited object transforms Irlinger's research on the history of the building into artistic research in a doubled sense: research as gesture and gesture as research.

In all of this, it remains unclear whether the endnotes decorate a missing text or mark a void that is yet to be filled. In either case, Irlinger's contribution allows for the blank pages' negation to be conceived as a potential that makes it possible to construct new forms of knowledge out of the architecture of a historical object, one that offers wholly different spaces and pathways of interconnection.

Einleitung
Julian Irlinger

An die Unterseite von Geschriebenem geheftete Anmerkungen sind Schauplatz für Gedanken, Kommentare, Belege oder Zitate, die als Desiderat der Äußerungen im Hauptteil eine Reihe von emotionalen Bedürfnissen stillen: der selbstkritische Zusatz zur getätigten Beobachtung; die orthodoxe Absicherung der Ursprünge des eigenen Gedankens; die auf reizvolle Weise noch offenstehenden Pfade der Argumentation. Sie markieren das Vor- und Zurück in jeder Arbeit am Text, bezeugen den Blick auf das, was andere sagten und dem, was weiterführen kann. In Julian Irlingers Beitrag zu *In Medias Res #2* schmücken allein Fußnoten die ansonsten leeren Seiten, mit denen der Künstler einen Text konstruiert, der die Leerstelle zu seinem Gegenstand macht.

Das formale Prinzip der Anmerkung macht wie selbstverständlich die Infrastruktur für eine konsequente, den Prämissen der Wissenschaftlichkeit verpflichteten Auseinandersetzung mit einem Objekt aus. Anhand von Quellenangaben, Verweisen und Zitatreferenzen schnürt jedwede historische Aufarbeitung – ganz so, wie sie auch in diesem Publikationsprojekt geführt wird – eine Architektur aus Wissen, Stück für Stück. Irlinger nutzt jene Methode und löst dabei seine konkrete Bezüglichkeit auf: Der grundlegende Text scheint verschwunden, die Aussagen des Haupttexts sind nicht zu erkennen, nur die hochgestellten Ziffern erlauben das ziellose Navigieren durch den luftleeren Raum der blauen Seite. Der Blick in die Fußnoten verrät ein Mosaik aus Einzeldetails über die Geschichte des Luftgaukommandos III und wird ergänzt durch Verweise auf das sich parallel ändernde Bau- und Eigentumsrecht, an dem sich die Entwicklung der politischen Systeme im Deutschland des 20. Jahrhunderts ablesen lässt. Die Fußnote als ausgestelltes Objekt macht Irlingers Recherche über die Geschichte des Baus zur künstlerischen Forschung im doppelten Sinne: Forschung als Geste und Geste als Forschung.

In alledem bleibt es unklar, ob die Fußnoten einen entfernten Text schmücken oder aber eine Leere markieren, die sich erst noch ausfüllen wird. In beiden Fällen erlaubt Irlingers Beitrag, die Negation der leeren Seite als Potenzial zu erkennen, das ermöglicht, aus der Architektur eines historischen Gegenstands eine neue Form des Wissens zu erbauen, die gänzlich verschiedene Räume und Flure der Verknüpfung bietet.

1

1

2

3

4

2

3

4

5

5

6,7

6,7

8

Julian Irlinger

9

8

10,11

9

12

10,11

13

14

12

13

14

15

15

Julian Irlinger

16

17

18

16

17

19

18

23

20

21

19

20

21

Julian Irlinger

1 Order to cut down approximately one-thousand pine trees. (See notification from the construction management to the district administration of Zehlendorf and the parks department there, dated May 14, 1936.)

2 Initially, construction projects were still subject to the legal guidelines, which were eased when all Wehrmacht construction projects were exempted from licensing requirements. (See application by the construction management from September 11, 1935 to the municipal Zehlendorf building inspector; communication to the district mayor of the Zehlendorf administrative district from April 6, 1937.)

3 "... at the same time, it is among the first monumental buildings bearing witness to the new German building spirit following the seizure of power by National Socialism." *Zentralblatt der Bauverwaltung* 24, no. 60 (1940): 345 [translated by Lisa Contag].

4 Fritz Fuß subsequently designed the administration building for Beton- und Monierbau AG. Today, the building is located at Sarrazinstraße 11–15 in Berlin-Friedenau.

5 The Luftgaukommando III buildings were barely affected by bomb damage in comparison to the rest of Berlin.

6 It was then controlled by the Verwaltungsamt für ehemaligen Reichsgrundbesitz (Administrative Office for Properties Formerly Owned by the Reich). Dennis Brzek and Junia Thiede, eds., *In Medias Res #1: Histories Read Across* (Milan: Mousse Publishing, 2021), 1.

7 Obvious connections to the Kaiserreich ended when it was renamed Kronprinzenallee on June 1, 1949.

8 The FU (Freie Universität) and BND (Federal Intelligence Service) were among the parties interested in the premises following the US army's withdrawal. See "Bund verkauft ehemaliges US-Hauptquartier," *Tagesspiegel*, September 24, 2010, https://www.tagesspiegel.de/berlin/bund-verkauft-ehemaliges-us-hauptquartier/1941778.html.

9 At the time it was privatized, the property housing Fluentum today was owned by the Bundesanstalt für Immobilienaufgaben (Institute for Federal Real Estate). See ibid.

10 See Bundesministerium der Finanzen ed., *Privatisierung in Deutschland* (1994): 27.

11 The law on unresolved property issues promoted the retransfer of land to former owners and heirs. It was morally considered reparation and functioned as a reprivatization in the sense of the market economy. Thus, on the one hand, the law created the legal context for the so-called restitution, and on the other hand, it facilitated the process of privatization throughout Berlin.

12 "Driven by the guiding principle of a lean and debt-free state, with cities and municipalities to be increasingly organized like profitable enterprises, far-reaching administrative reforms occurred at the time that set in motion, or at least encouraged, a practice of privatization: land, enterprises, and housing were released from the public sector." See Andrej Holm, "Privatisierungspolitik in Berlin seit 1990," *ARCH+* 241 (December 2020): 97 [translated by Lisa Contag].

13 The winning bid amounted to fifteen million euros. See Christian Hunziker, "Wohnen, wo die Amerikaner wachten," *Tagesspiegel*, August 6, 2011, https://www.tagesspiegel.de/wirtschaft/wohnen-wo-die-amerikaner-wachten/4467034.html.

14 Owners at fifty percent each are the Prinz von Preussen

1 Anordnung der Abholzung von circa 1.000 Kieferbäumen. (Siehe Mitteilung der Bauleitung an die Bezirksverwaltung Zehlendorf und das dortige Gartenbauamt vom 14.05.1936.)

2 Zu Beginn unterlag der Bau noch sämtlichen legalen Prozessen, die gelockert wurden, als Baumaßnahmen der Wehrmacht von Genehmigungspflichten befreit worden sind. (Siehe Antrag vom 11.09.1935 von der Bauleitung bei der Baupolizei Zehlendorf; Mitteilung vom 06.04.1937 an den Bezirksbürgermeister des Verwaltungsbezirks Zehlendorf.)

3 „...zugleich gehört er zu den ersten monumentalen Bauten, die nach der Machtergreifung durch den Nationalsozialismus von der neuen deutschen Baugesinnung zeugen durfte." Siehe *Zentralblatt der Bauverwaltung* 24 (60), Berlin 1940, S. 345.

4 Fritz Fuß entwarf anschließend noch das Verwaltungsgebäude für die Beton- und Monierbau AG. Das Gebäude steht heute in Berlin-Friedenau unter der Adresse Sarrazinstraße 11-15.

5 Die Gebäude des Luftgaukommandos III wiesen einen für Berlin vergleichsweise geringen Bombenschaden auf.

6 Dann unterstand es dem Verwaltungsamt für ehemaligen Reichsgrundbesitz. Vgl. Dennis Brzek und Junia Thiede (Hg.), *In Medias Res #1. Histories Read Across*, Mailand 2021, S.1.

7 Eine offensichtliche Verbindung zum Kaiserreich besteht seit der Umbenennung der Kronprinzenallee am 01.06.1949 nicht mehr.

8 Seit dem Abzug des US-Militärs hatten u.a. die FU und der BND Interesse an dem Gelände. Vgl. „Bund verkauft ehemaliges US-Hauptquartier", in: *Der Tagesspiegel* [24.09.2010], URL: https://www.tagesspiegel.de/berlin/bund verkauft-ehemaliges-us-hauptquartier/1941778.html (letzter Zugriff: 11.02.2022).

9 Zum Zeitpunkt der Privatisierung war das Gelände, auf dem sich Fluentum heute befindet, im Besitz der Bundesanstalt für Immobilienaufgaben. Vgl. *Der Tagesspiegel* (wie Anm. 8).

10 Vgl. Bundesministerium der Finanzen (Hg.), *Privatisierung in Deutschland*, Bonn 1994, S.27.

11 Das Gesetz für offene Vermögensfragen förderte die Rückübertragung von Grundstücken an Alteigentümer*innen und Erb*innen. Es wurde moralisch als eine Wiedergutmachung verbucht und funktionierte als Reprivatisierung im Sinne der Marktwirtschaft. Das Gesetz schaffte so zum einen den legalen Kontext für die sogenannte Restitution, zum anderen begünstigte es den Prozess der Privatisierung in ganz Berlin.

12 „Angetrieben vom Leitbild eines schlanken und schuldenfreien Staates, dessen Städte und Kommunen zunehmend wie profitable Unternehmen organisiert sein sollten, kam es damals zu tiefgreifenden Verwaltungsreformen, die eine Praxis der Privatisierung in Gang setzten oder zumindest begünstigten: Grundstücke, Unternehmen und Wohnungen wurden aus der öffentlichen Hand gegeben." Vgl. Andrej Holm, „Privatisierungspolitik in Berlin seit 1990", in: *ARCH+* 241, Berlin 2020, S. 97.

13 Das erfolgreiche Gebot lag bei 15 Millionen Euro. Vgl. Christian Hunziker, „Wohnen, wo die Amerikaner wachten", in: *Der Tagesspiegel* [06.08.2011], URL: https://www.tagesspiegel.de/wirtschaft/wohnen-wo-die-amerikaner-wachten/4467034.html (letzter Zugriff: 11.02.2022).

14 Eigentümer mit jeweils 50 % sind die Prinz von Preussen

Grundbesitz AG located in Bonn and Terraplan GmbH located in Nuremberg, who are jointly responsible for The Metropolitan Gardens.
15 A total amount of 110 million euros was invested into The Metropolitan Gardens. The price per square meter ranges from 4,700 to 5,500 euros. See Martinus Schmidt, "Metropolitan Gardens vor der Fertigstellung," *Berliner Woche*, September 2, 2013, https://www.berliner-woche.de/dahlem/c-sonstiges/metropolitan-gardens-vor-der-fertigstellung_a34714.
16 Construction and renovations were completed in 2014.
17 In eight buildings, 295 residential condominiums with a total of 17,500 square meters of living space have been created. See "The Metropolitan Gardens – Berlin Dahlem," https://www.prinzvonpreussen.eu/referenzen/the-metropolitan-gardens/.
18 See Florine Schüschke: "Ausverkauft: Die Privatisierung von Landeseigenem Grundbesitz in Berlin," *ARCH+* 241 (December 2020): 79.
19 Markus Hannebauer acquired this section of the building in 2016 and commissioned architecture firm Sauerbruch Hutton with its conversion.
20 See https://www.fluentum.org/en/about.html.
21 The conversion of the central building, which today is the place for Fluentum's exhibitions as well as Hannebauer's private residence, began in 2017 and was completed in 2019.

Grundbesitz AG mit Sitz in Bonn und die Terraplan GmbH mit Sitz in Nürnberg, die gemeinsam hinter dem Bauprojekt The Metropolitan Gardens stehen.
15 In The Metropolitan Gardens wurden insgesamt 110 Millionen Euro investiert. Der Preis pro Quadratmeter liegt bei 4.700 bis 5.500 Euro. Vgl. Martinus Schmidt, „Metropolitan Gardens vor der Fertigstellung", in: *Berliner Woche* [02.09.2013], URL: https://www.berliner-woche.de/dahlem/c-sonstiges/metropolitan-gardens-vor-der-fertigstellung_a34714 (letzter Zugriff: 11.02.2022).
16 2014 wurden der Bau und die Sanierung abgeschlossen.
17 In acht Gebäuden sind 295 Eigentumswohnungen mit insgesamt 17.500 m² Wohnfläche entstanden. Vgl. URL: https://www.prinzvonpreussen.eu/referenzen/the-metropolitan-gardens/ (letzter Zugriff: 14.02.2022).
18 Vgl. Florine Schüschke, „Ausverkauft. Die Privatisierung von Landeseigenem Grundbesitz in Berlin", in: *ARCH+* 241, Berlin 2020, S. 79.
19 Markus Hannebauer hat den Gebäudeteil 2016 erworben und das Architekturbüro Sauerbruch Hutton mit dem Umbau beauftragt.
20 Vgl. URL: https://www.fluentum.org/en/about.html (letzter Zugriff: 11.02.2022).
21 Der Umbau des Mittelstücks, in dem Fluentum heute Ausstellungen zeigt, und der darüberliegenden Privaträume begann 2017 und wurde 2019 abgeschlossen.

Julian Irlinger is an artist living and working in Berlin. In his practice he approaches past events in sight of future conflicts. His work was shown at Galerie Thomas Schulte, Berlin; Artists Space, New York; Damien & The Love Guru, Brussels; Galerie Wedding, Berlin; and MMK Frankfurt, among others.

Dennis Brzek and Junia Thiede
Sets of Protocols—Collages Dedicated to Art and
Design Objects, ca. 1938–1978

The following pages aim to uncover the dense enmeshment of political agendas within the architecture and the material culture of the Luftgaukommando III, and later the US headquarters, via an extensive series of image and text collages. This associative (re)search for traces on the building itself unfolds over several double-page spreads, bringing together remnants of the various artisanal and aesthetic practices of the political systems that have met within its architecture since 1936. The collages, created in collaboration with graphic design studio HIT, illustrate something like condition reports that juxtapose and reprocess specific historical fragments while looking from a contemporary vantage point.

Index of collages:

Dennis Brzek und Junia Thiede
Sets of Protocols – Collagen zu Kunst- und Design-gegenständen, ca. 1938–1978

Auf den folgenden Seiten wird die enge Verzahnung politischer Agenda mit Architektur und der materiellen Kultur des Luftgaukommandos III und späteren US-Hauptquartiers anhand einer umfangreichen Strecke aus Bild- und Textcollagen freigelegt. Die assoziative Spurensuche am Bau entspinnt sich auf mehreren Doppelseiten, die die verschiedenen kunsthandwerklichen und ästhetischen Praktiken der mit dem Gebäude seit 1936 in Verbindung stehenden politischen Systeme zusammenführt. Die Collagen, in Zusammenarbeit mit dem Grafikstudio HIT entstanden, bilden dabei Zustandsaufnahmen, die aus dem Jetzt heraus spezifische Fragmente aus der Geschichte nebeneinanderstellen und neu aufbereiten.

Verzeichnis der Collagen:

p. 36 Cut-glass work, Alfred Mahlau, 1936–1938
Lübeck artist Alfred Mahlau mainly created prints, graphics, and cut-glass works. During the Nazi era, he was granted numerous exhibitions and public commissions. Designs of windows in Wehrmacht buildings were an important source of income for him. Among other works, he conceived major cut-glass works in the Luftgaukommandos in Berlin and Dresden— works that no longer exist—in which he illustrated the aspirations of the Luftwaffe with turgid, melodramatic metaphors.

p. 38 *Laufender Mann*, Georg Kolbe, 1937
Georg Kolbe is one of the few protagonists associated with the Luftgaukommando's history that is still considered art-historically significant today. A sought-after artist since the early twentieth century, whose practice focused primarily on the depiction of humans, Kolbe was commissioned to produce a sculpture for the outside area of the complex. Archival images and logs illustrating the sculpture's surprising trajectory in the immediate aftermath of the war also hint at the ongoing debate surrounding his work.

p. 40 Transformation into US headquarters,
 Eckart Muthesius, 1945
Eckart Muthesius is remembered today almost exclusively as a celebrated furniture designer and creator of the Manik Bagh Palace, a Gesamtkunstwerk of Modernism in India. His little-known private residences, villas, and hospitals in postwar Germany, on the other hand, have mostly been forgotten. Muthesius was forced to return to Germany when the war broke out and then worked for the regime. After 1945, the OMGUS (Office of Military Government, United States) commissioned him to repair numerous buildings used by the Nazis to prepare them for use by the US Mission, including the former Luftgaukommando.

p. 42 Doughboy sculpture, Ernst Kunst, ca. 1950
The volume of photographic documentation of US soldiers' everyday life in and around Dahlem increased in the wake of the building's use as US headquarters. A sculpture representing a so-called doughboy was the most prominent work of art to be placed in what is today Fluentum's exhibition space: a symbolic representation intended to inspire young soldiers since the First World War. Today held by the Allied Museum, the sculpture formed the visual center of the marble-clad hall and provided an opportunity for numerous photo ops.

p. 44 Exhibitions at Crumb Hall Library, ca. 1950s
The attempt to sketch out an art and exhibition history of the building also offers insight into the more general social function of art in postwar Berlin. The Crumb Hall Library, part of the services offered to the US military stationed in Berlin, hosted smaller exhibitions of prints by international artists. These included local amateurs, as well as individuals such as Juro Kubicek, the first German artist to travel to Kentucky on a studio grant after the war.

p. 46 Lucius D. Clay Memorabilia, ca. 1978
The US headquarters' visual culture was dominated by the face of General Lucius D. Clay, the former military governor in Germany, who was celebrated for his role during the 1948–49 Berlin Airlift. The US headquarters was renamed after him posthumously. The arrangement of a drawing and a funeral wreath commemorated the late Clay in 1978 and helped to cement his iconic significance for the US headquarters.

S. 36 Glasschliffarbeiten, Alfred Mahlau, 1936–1938
Der Lübecker Künstler Alfred Mahlau schuf vor allem Grafiken sowie Glasarbeiten und wurde zur NS-Zeit mit zahlreichen Ausstellungen und öffentlichen Aufträgen bedacht. Eine wichtige Einkommensquelle bot ihm die künstlerische Gestaltung von Fenstern in den Gebäuden der Wehrmacht. So entwarf und realisierte er beispielsweise heute nicht mehr erhaltene Werke in den Luftgaukommandos in Berlin und Dresden. In diesen illustrierte er mit schwülstiger, pathetischer Metaphorik die Bestrebungen der Luftwaffe.

S. 38 *Laufender Mann*, Georg Kolbe, 1937
Einer der wenigen Charaktere, die in Verbindung mit dem Luftgaukommando III stehen und auch heute noch kunsthistorisch bedeutend sind, ist Georg Kolbe. Seit dem frühen 20. Jahrhundert ein gefragter Künstler, der hauptsächlich mit Menschendarstellungen arbeitete, wurde Kolbe beauftragt, eine Skulptur für den Außenbereich des Gebäudekomplexes zu schaffen. In Archivbildern und Protokollen, die die überraschenden Wege der Skulptur in der unmittelbaren Zeit nach dem Kriegsende zeigen, lässt sich auch die andauernde Diskussion um sein Werk ablesen.

S. 40 Umgestaltung zum US-Hauptquartier,
 Eckart Muthesius, 1945
Eckart Muthesius wird heute fast ausschließlich als gefeierter Möbeldesigner und Schaffer des Manik Bagh Palasts, ein Gesamtkunstwerk der Moderne in Indien, erinnert. Meist vergessen sind seine wenig bekannten Privatwohnhäuser, Villen und Krankenhäuser im Nachkriegsdeutschland. Muthesius kehrte bei Ausbruch des Zweiten Weltkriegs unfreiwillig nach Deutschland zurück und baute Zweckbauten für das Regime. Nach 1945 beauftragte ihn das OMGUS mit der Instandsetzung zahlreicher vom NS genutzter Bauten, um sie für die Nutzung durch die US-Mission vorzubereiten, zu dem auch das ehemalige Luftgaukommando in Berlin-Dahlem zählte.

S. 42 Doughboy-Statue, Ernst Kunst, ca. 1950
Mit dem Anbruch der Nutzung des Gebäudes als US-Hauptquartier steigt auch die Anzahl von fotografischer Dokumentation des Lebensalltags des US-Militärs in und um Dahlem. Der Doughboy war das prominenteste Kunstwerk, das im heutigen Ausstellungsraum von Fluentum aufgestellt wurde: eine symbolische Repräsentationsfigur, die seit dem Ersten Weltkrieg junge GIs inspirieren sollte. Heute vom Alliierten-Museum eingelagert, war die Skulptur das visuelle Zentrum der marmorverkleideten Halle und bot Gelegenheit für zahlreiche Fotoinszenierungen.

S. 44 Ausstellungen in der Crumb Hall Library, ca. 1950er
Der Versuch, eine Kunst- und Ausstellungsgeschichte des Gebäudes zu skizzieren, bietet auch Einblick in die soziale Funktion von Kunst im Nachkriegsberlin. Die Crumb Hall Library, Teil des Angebots für das in Berlin stationierte US-Militär, veranstaltete kleinere Ausstellungen mit Druckgrafiken von internationalen Künstlerinnen und Künstlern. Darunter befanden sich lokale Amateure, aber auch Personen wie Juro Kubicek, der als erster deutscher Künstler in der Nachkriegszeit mit einem Atelierstipendium nach Kentucky reiste.

S. 46 Memorabilia zu Lucius D. Clay, ca. 1978
Die visuelle Kultur des US-Hauptquartiers wird geprägt vom Gesicht des Generals Lucius D. Clay, ehemaliger Militärgouverneur in Deutschland, der für seine Rolle während der Berliner Luftbrücke 1948/49 gefeiert wurde. Das US-Hauptquartier wurde nach seinem Tod ihm gewidmet. In der Halle kommemorierte ein Arrangement aus einer Zeichnung sowie einem Trauerkranz den verstorbenen Clay und manifestierte seine ikonische Bedeutung für das Hauptquartier.

485 383

Dresden-Strehlen

Ehem. Luftgaukommando,
August-Bebel-Str.
um 1939; W. Kreis

O-Flügel
Fenster (EG u. 1. OG) u. Relief-
tafeln mit Tierkreiszeichen Waage,
Skorpion u. Schütze

6x7
H. Reinecke
März 1995

Sächsische Landesbibliothek
DEUTSCHE FOTOTHEK DRESDEN

Kunstwiss./Musik	Geschichte	Geowiss.	Naturwiss.	Technik	Volksbildg. Sport	Volkskunde	BiK	AOK	SWK
5851 4 5854	4	~	—	—	—	—	/	D 20	Relief a. d. Lieht. Tierkreiszeichen – Waage – Skorpion – Schütze

490 949

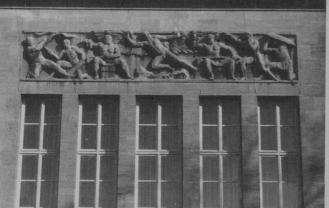

490 949

Dresden-Strehlen

Ehem. Luftgaukommando, August-Bebel-
Str.
um 1939; W. Kreis

Hauptgebäude, Mittelbau
Fenster u. Kriegerfries

6x7
H. Reinecke
März 1995

Sächsische Landesbibliothek
DEUTSCHE FOTOTHEK DRESDEN

Kunstwiss./Musik	Geschichte	Geowiss.	Naturwiss.	Technik	Volksbildg. Sport	Volkskunde	BiK	AOK	SWK
5851 (A) 5854	(4)	~	—	—	(856)	~	/	D 20	(Risalit-Mittelbau) Ornamentik-Kriegsfries Krieg – Kriegs-Bik

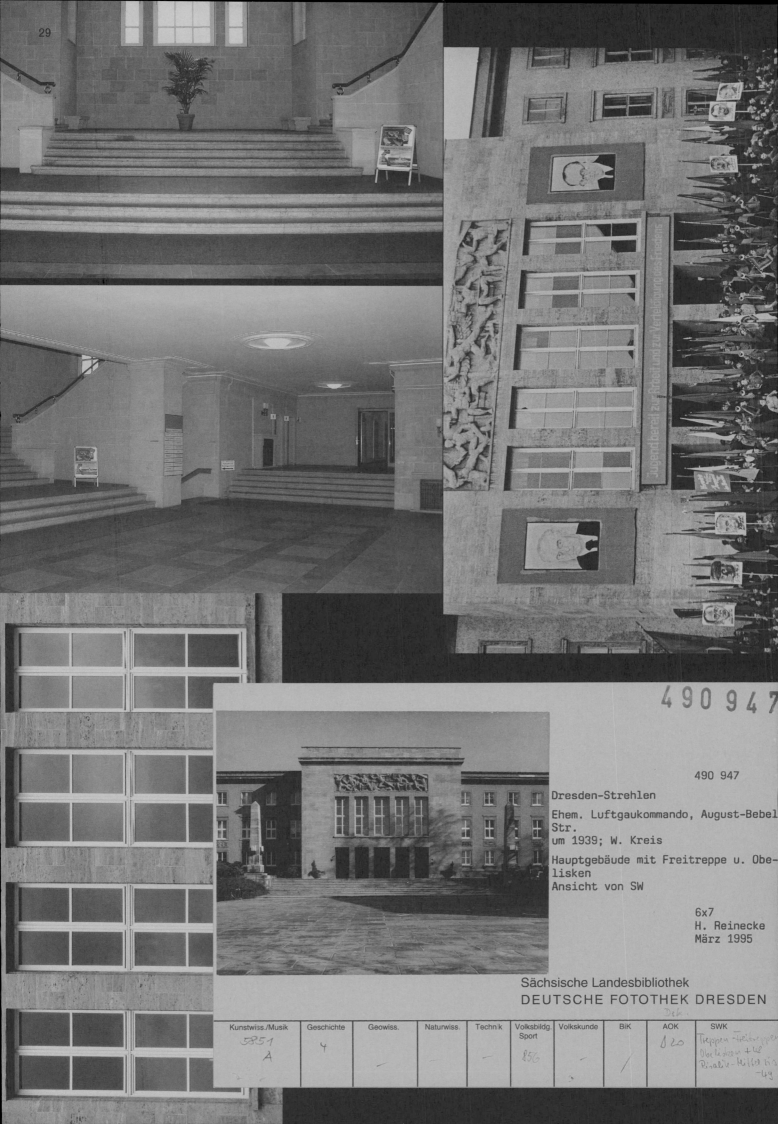

490 947

490 947

Dresden-Strehlen

Ehem. Luftgaukommando, August-Bebel-
Str.
um 1939; W. Kreis

Hauptgebäude mit Freitreppe u. Obe-
lisken
Ansicht von SW

6x7
H. Reinecke
März 1995

Kunstwiss./Musik	Geschichte	Geowiss.	Naturwiss.	Technik	Volksbildg. Sport	Volkskunde	BiK	AOK	SWK
5851 A	4				856		/	820	Treppen-Freitreppen Obelisken +46 Pinakir-Mittel fis -49

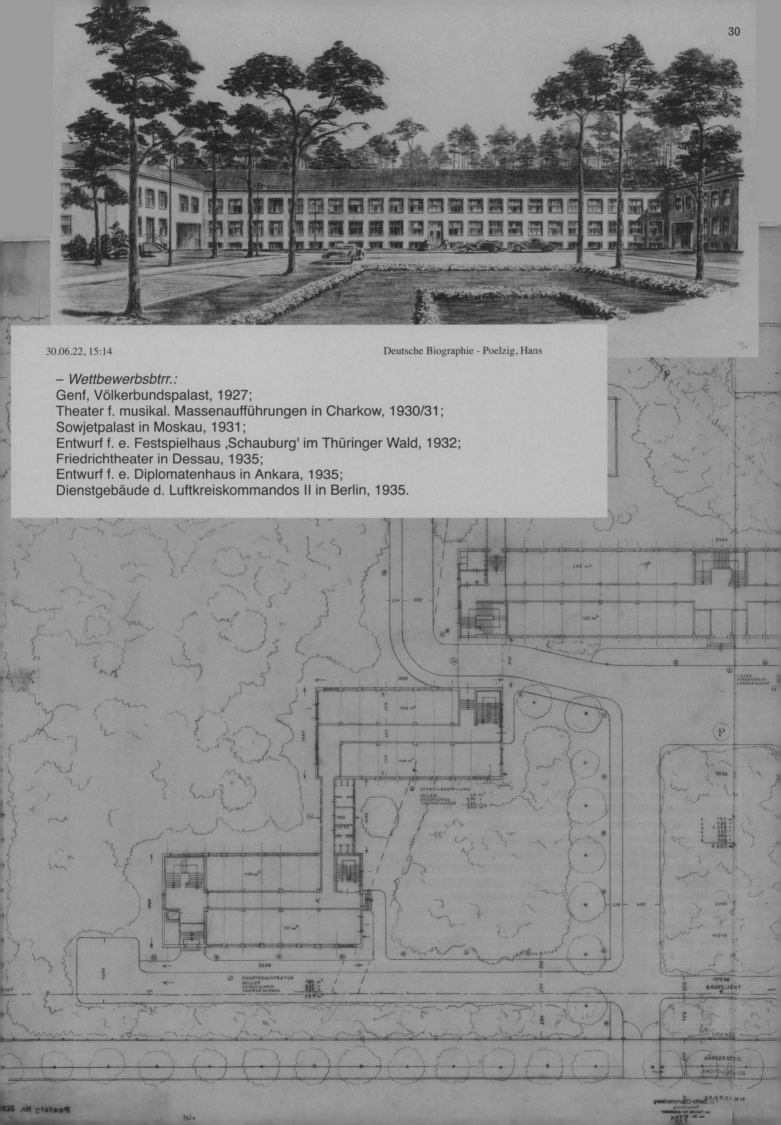

30.06.22, 15:14　　　　　　　　　　　Deutsche Biographie - Poelzig, Hans

– *Wettbewerbsbtrr.:*
Genf, Völkerbundspalast, 1927;
Theater f. musikal. Massenaufführungen in Charkow, 1930/31;
Sowjetpalast in Moskau, 1931;
Entwurf f. e. Festspielhaus ‚Schauburg' im Thüringer Wald, 1932;
Friedrichtheater in Dessau, 1935;
Entwurf f. e. Diplomatenhaus in Ankara, 1935;
Dienstgebäude d. Luftkreiskommandos II in Berlin, 1935.

LAGEPLAN 1:500.

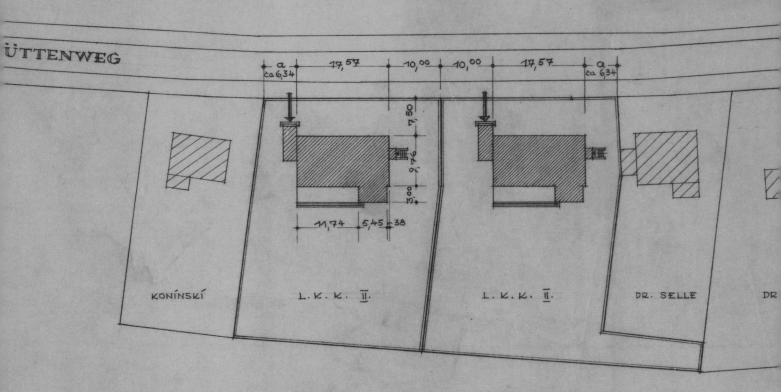

ÜTTENWEG

a
ca 6,34 17,57 10,00 10,00 17,57 a
ca 6,34

7,50

9,76

3,00

11,74 5,45 38

KONINSKI L.K.K. Ⅱ. L.K.K. Ⅱ. DR. SELLE DR

NEUBAUGELÄNDE DES L.K.K. Ⅱ.

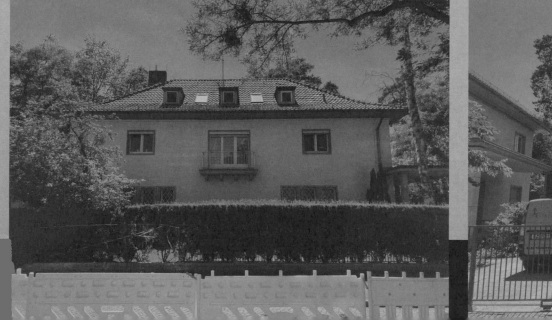

Landesdenk - Berlin

🏠 ▸ Denkmale

Denkmal

Dienstwohn

Obj.-Dok.-Nr.	
Bezirk:	
Ortsteil:	
Strasse:	Hüttenweg
Hausnummer:	21 & 25
Denkmalart:	Gesamtanlage
Sachbegriff:	Wohnhausgruppe
Datierung:	1935-1937
Entwurf:	Sagebiel, Ernst (Architekt)

Noch mehr Wohnraum als die Unteroffiziere der Luftwaffe hatten die höheren Offiziere zur Verfügung, die die beiden nebeneinander liegenden Dienstwohnhäuser am Hüttenweg 21 und 25 bezogen. Die von Ernst Sagebiel entworfenen, identischen Häuser wirken wesentlich eleganter und weniger heimattümelnd. (1) 1935-37 erbaut, verkörpern sie das repräsentative Einfamilienwohnhaus der 1930er Jahre wie es vergleichsweise von Fritz August Breuhaus de Groot mit Erfolg entwickelt wurde. Die sich auf Bautraditionen berufende, zurückhaltend moderne Architektursprache dieser Häuser wurde von den neuen Machthabern akzeptiert. Kennzeichnend sind die flächige, vornehme Wandwirkung mit werksteinumrahmten Haustüren und sprossenlosen Fenstern, die zum Band zusammengefasst sein können, verbunden mit repräsentativ wirkenden Bauteilen wie hier einer seitlichen Veranda mit schlanken Werksteinpfeilern am Hauseingang - ein Baumotiv, das Sagebiel häufig verwendete. Dennoch kam auch er, der zur gleichen Zeit die Göring´sche Machtzentrale, das Reichsluftfahrtministerium an der Wilhelmstraße erbaute, nicht ganz ohne Zutaten der ideologischen "Baukultur" des Nationalsozialismus aus. So fehlt nicht der funktionslose "Führerbalkon", den Sagebiel im Obergeschoss der Diele zuordnete. Der Grundriss der Häuser ist dagegen zweckmäßig auf den Rang und die Bedürfnisse der Luftwaffenoffiziere ausgerichtet. Klar wird in Längsrichtung der Wirtschafts- und Treppenhallenbereich von den Gesellschafts-, Wohn- und Schlafzimmern getrennt. Letztere liegen aufgereiht zum Garten, zu dem sich im Erdgeschoss eine breite Terrasse mit Pergola und im Obergeschoss ebenfalls eine Terrasse über dem Wintergarten öffnen.

--

(1) Ernst Sagebiel (1892-1970) hatte als Architekt vor allem in der Zeit des Nationalsozialismus Bedeutung erlangt. Er entwarf das Reichsluftfahrtministerium und den Flughafen Tempelhof. Vgl.: Dittrich, Elke: Ernst Sagebiel, Leben und Werk, Berlin 2005, S. 196-198.

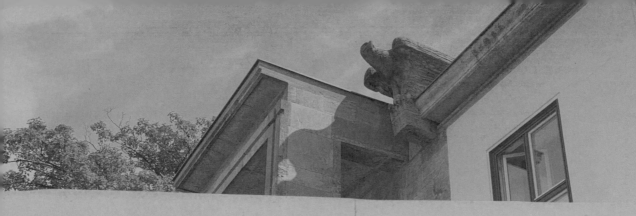

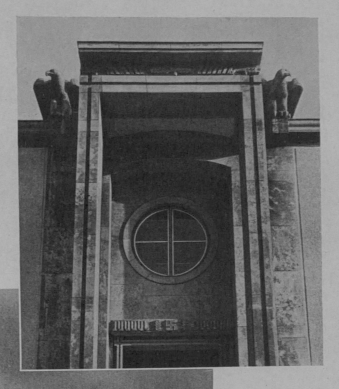

Unten: Blick von einem der Portalbauten zum Hauptgebäude. Rechts: Einzelheit der Portalausbildung. Adler und Friese von Professor Willy Meller, Köln.

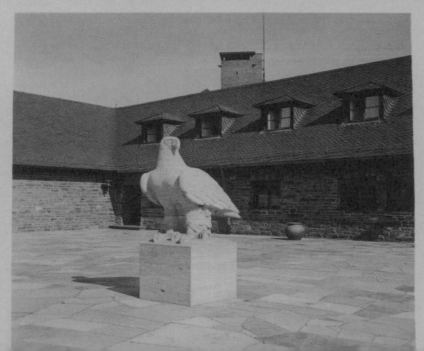

Das Dienstgebäude des Luftgaukommandos Berlin.

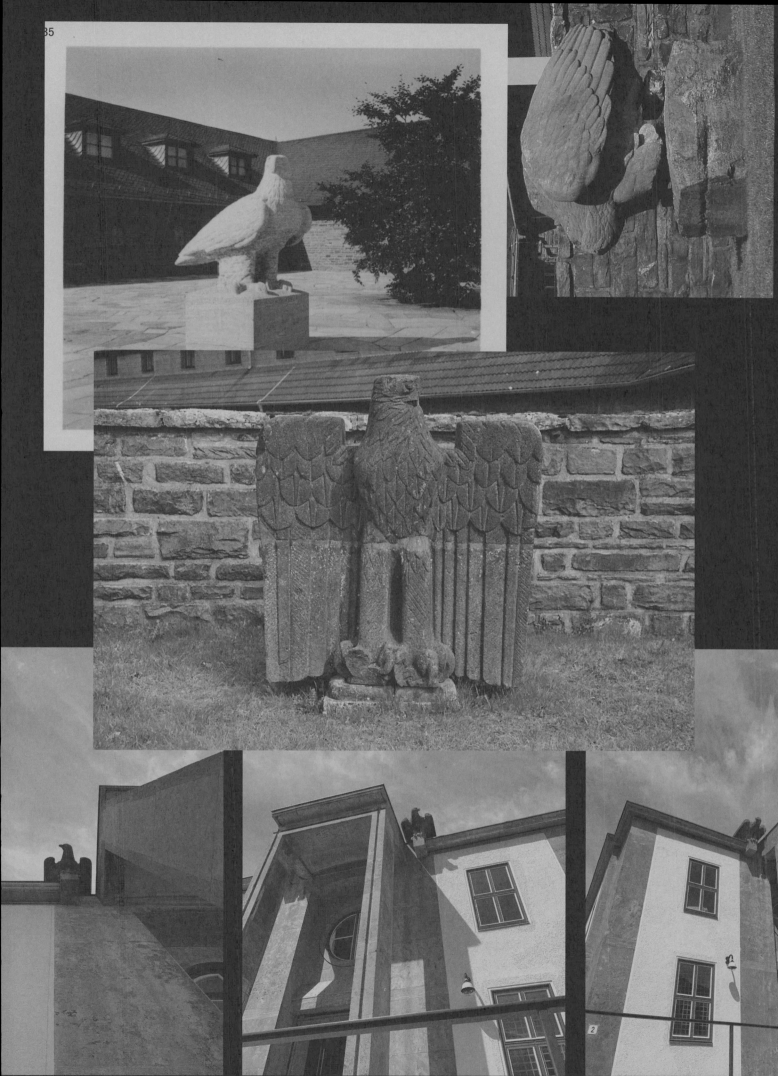

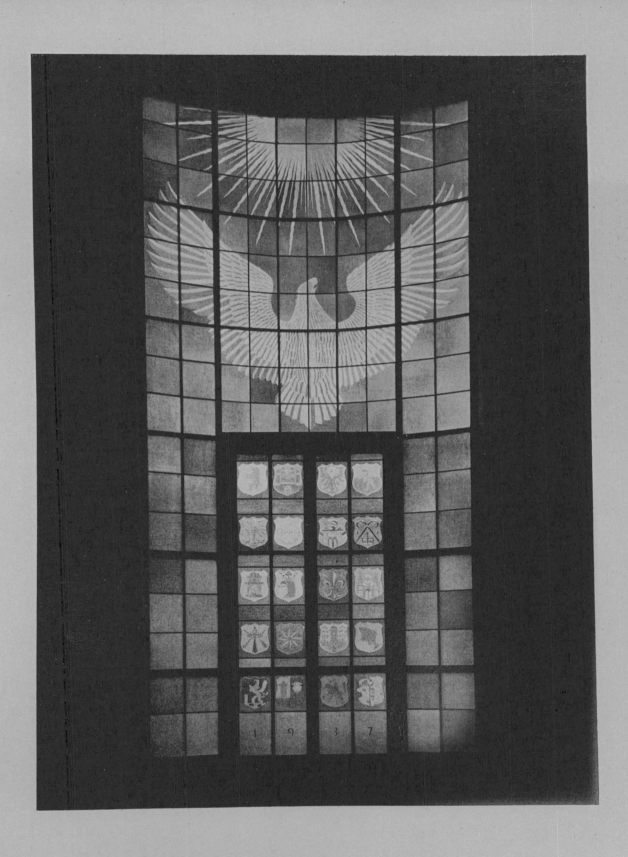

Fenster im Haupttreppenhause des Hauptgebäudes (vgl. S. 350). Glasschliffarbeiten von Mahlau, Lübeck.

Dem "Laufenden Mann" ging ein plastisches Modell von 95 cm Höhe voraus. Mithilfe einer mechanischen Vergrößerung durch die Bildgießerei Noack entwickelte Kolbe das große Gipsmodell; die Bronze war im Dezember 1937 fertig gestellt. Die Statue war im Auftrag des "Reichsluftfahrtministeriums" für das "Luftgaukommando III" (anfangs Luftkreiskommando II bezeichnet) geschaffen worden.

Nach einem engeren Wettbewerb 1935, den der Architekt Fritz Fuß gegen Hans Poelzig und Heinrich Straumer gewonnen hatte, wurden die Kasernengebäude an der Kronprinzenallee (später Clay-Allee) in Berlin-Dahlem errichtet. Die große Kolbe-Bronze wurde vor dem Kasino auf einer Rasenfläche im seitlichen Teil der Anlage aufgestellt. 1945 wurde die Dahlemer Kaserne zum Hauptquartier der Amerikaner in der Viersektorenstadt Berlin.

Die Statue war vor oder nach Kriegsende gestohlen worden und wurde dabei an der Plinthe beschädigt (spätere Reparatur durch die Gießerei Noack). 1947 beschlagnahmte die Polizei das Werk in Berliner Privatbesitz. Die Identifizierung der Figur nahm Georg Kolbe vor. Er informierte am 29. Juli Adolf Jannasch vom Kunstamt der damals noch nicht geteilten Stadt. Kurt Reutti von der "Zentralstelle zur Erfassung ... von Kunstwerken" befragte Kolbe in einem Schreiben vom 12.08.1947 über die ursprüngliche Bestimmung der Statue. Beide haben später dazu ungenaue Angaben gemacht. Reutti stellte 1954 für den Haupttreuhänder für NSDAP-Vermögen eine Liste der von ihm sichergestellten Werke aus NS-Besitz zusammen, darin erwähnte er die Bronze versehentlich doppelt oder sogar dreifach (GStA PK, VI, HA NL, Reutti, Nr. 7, Bl. 104v, 106); Jannasch verortete sie manchmal im Göhrings Reichsluftfahrtministerium.

Nach ihrer Auffindung war die Figur anscheinend im Gewahrsam des Hochkommissars für die Westzonen Deutschlands (HICOG). 1951 wurde sie der Galerie des 20. Jahrhunderts übergeben, die seit 1968 mit der Neuen Nationalgalerie vereinigt ist. Das Werk fehlt jedoch im ersten Bestandskatalog (Haftmann 1968).

Ursel Berger

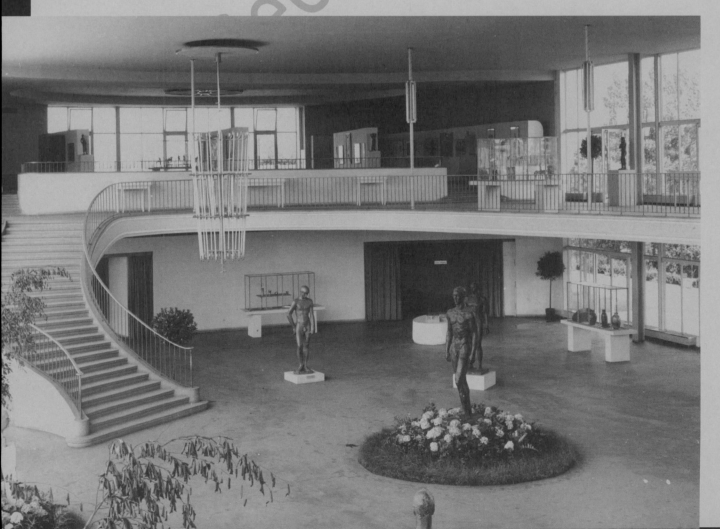

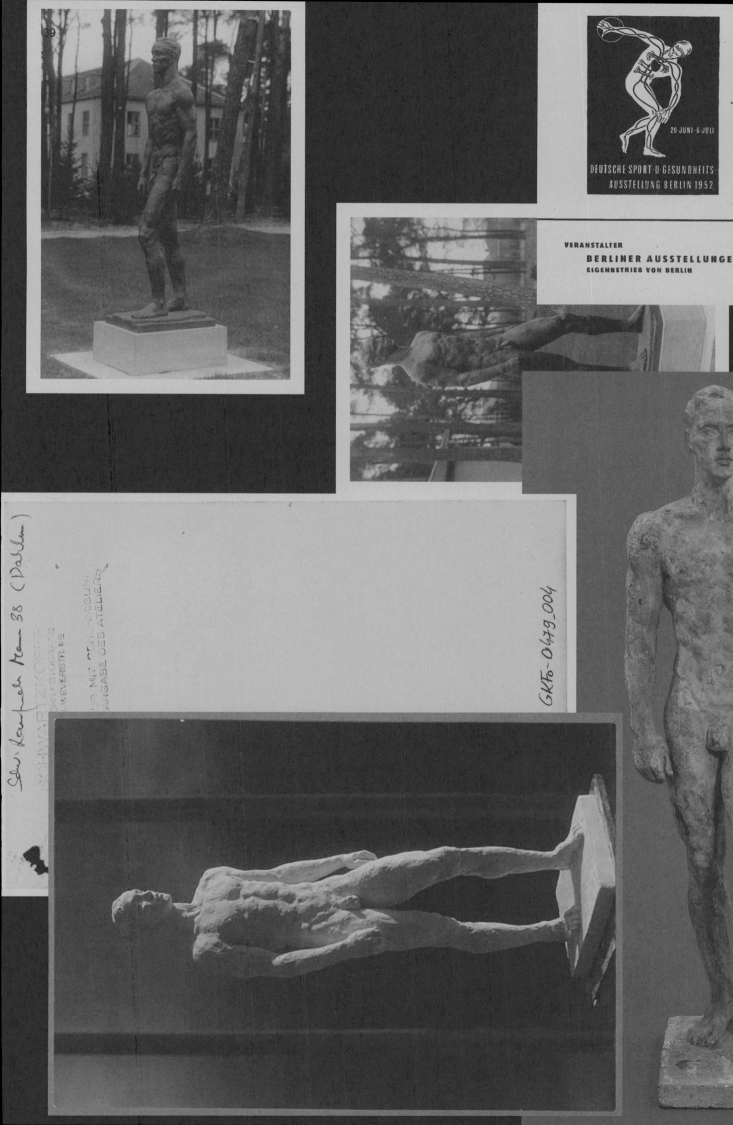

39

20·JUNI·6·JULI

DEUTSCHE·SPORT·U·GESUNDHEITS·
AUSSTELLUNG·BERLIN·1952

VERANSTALTER
BERLINER AUSSTELLUNGEN
EIGENBETRIEB VON BERLIN

GKfb-0479_004

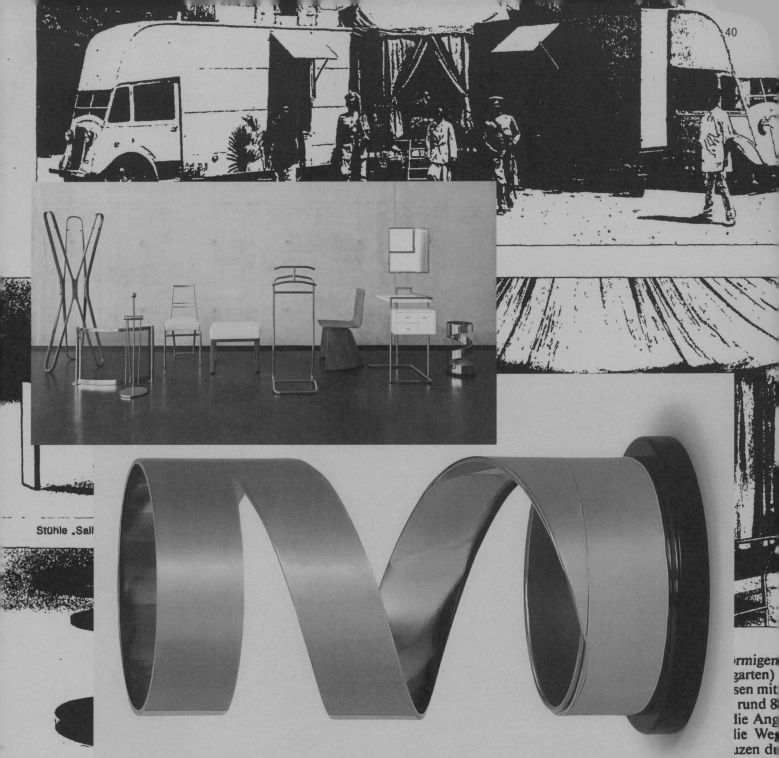

Stühle „Sall

Tisch „Holkar",
dem Stempel deutscher Form-Anschauung"

eine Wiederauferstehung – als Serien-
produkte eines Möbelherstellers. Neu
aufgelegt wurden zum Beispiel der aus
Chromrohren gebogene Stumme Diener
„Mandu" (540 Mark), der teilverspiegel-
te Lederstuhl „Sally" (1400 Mark) und
der schwarz gebeizte Holztisch „Holkar"
(2800 Mark).

Prachtstück der neuen Kollektion, die
von den Münchner Vereinigten Werk-
stätten als „ein Juwel des Art Déco" of-
feriert wird, ist der 15 000 Mark teure
„Rote Sessel", ein knallrotes Ledermon-
strum auf Metallkufen. In die beiden

Muthesius' originelle Möbelmodelle
stehen nun als „wieder vorzeigbare Re-
likte" für jenes zeitgenössische Gesamt-
kunstwerk, das der – bislang in der Bun-
desrepublik fast unbekannt gebliebene –
Architekt nach fünfjähriger Arbeit 1934
schlüsselfertig übergab.

Beeinflußt vom Gedankengut seines
Vaters Hermann Muthesius, eines be-
rühmten Architekten und Mitbegrün-
ders des Deutschen Werkbundes, schuf
Muthesius in der Provinzstadt Indore,
rund zwölf Bahnfahrtstunden von Bom-
bay entfernt, ein „vollkommenes Denk-
mal des Modernismus", wie Fachleute
vom Berliner Kunstgewerbemuseum
kürzlich das Bauwerk nannten.

ein eigener, außen liegender Gar
schaffen.

Die nach Bauhaus-Vorbild üb
gend streng geformten Möbel w
ebenso wie die meisten Säulen
schwarzem Ebenholz gefertigt; sch
und orangefarbene Teppiche zeich
geometrische Muster auf die Ma
fußböden. „Der Palast", schrieb
anerkennend die „Berliner Illust
„trägt den Stempel deutscher For
schauung unserer Zeit."

Weil die Wände wegen zu hohe
feuchtigkeit in den Regenmonate
der tapeziert noch mit Seide bes
werden konnten, entschloß sich M
sius zu einer extravaganten Lösur

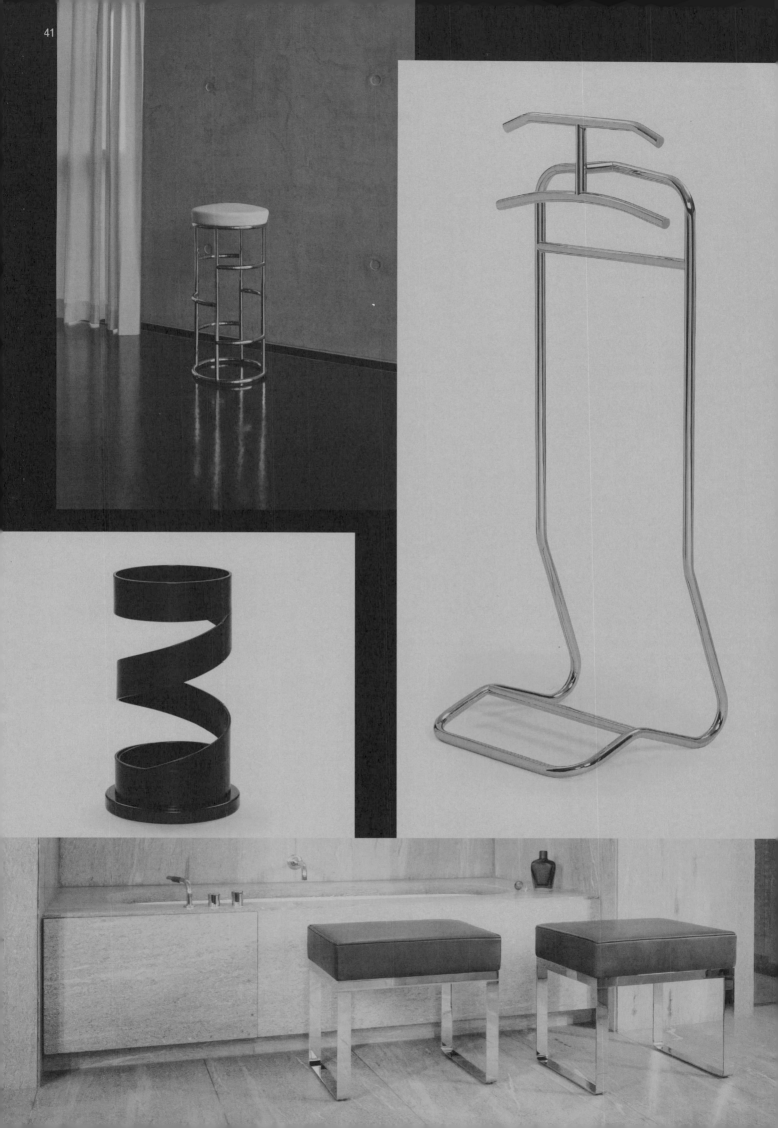

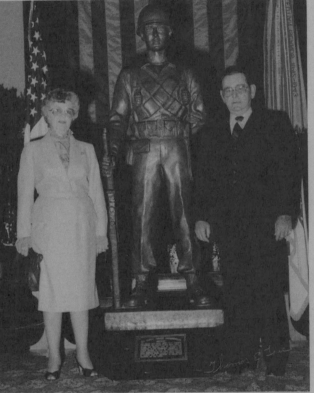

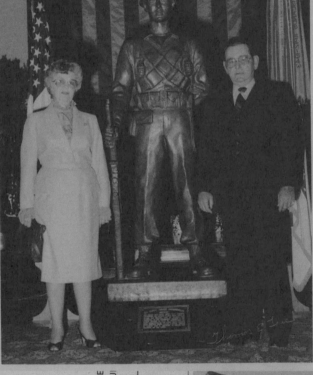

The doughboy's back

...of Oakhill, W.Va., poses ...t Berlin statue "The ...which he served as a ...ago. Love, who was a platoon sergeant with Co E, 3rd Inf Regt, at the time, was immortalized by Berlin artist Ernst Kunst, but never saw the statue until this visit to West Berlin.

AP photo

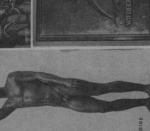

G. MARCKS

G. KOLBE

R. SCHEIBE

'Doughboy' represents infantry

He's six feet tall and weighs in at 1,000 pounds. He was brought to the position of parade rest by his sculptor and hasn't flexed a muscle since.

"The Infantryman" or "Doughboy" as he is commonly referred to, is a life-size replica of the American soldier as he looked during World War II and the Korean Conflict. He was created by German sculptor Ernst Kunst and installed in what is now Bldg. 1, Gen. Lucius D. Clay Headquarters in October 1946.

The statue, cast in bronze is made of plaster of paris mounted on a steel frame. Maj. Gen. Frank Keating, the third United States commandant in

Love was selected after a stiff competition, in which each battalion commander entered his best soldier. Love, a native of West Virginia, and platoon sergeant for Company E, 3rd Infantry Regiment, served in combat with the 26th Infantry Division which was assigned to Gen. George Patton's Third Army. He also was awarded a Combat Infantryman's Badge.

The statue of "The Infantryman" is as impressive as were the soldiers of the era. Standing in the rotunda of Bldg. 1, for both visitors and soldiers to see, he is flanked by the 50 state flags, the U. S. Colors, the flags from the six U. S. territories and the U. S. Army flag. He is dressed in full field _____ with an M-1 rifle in his right hand.

front of 'The Infantryman' because I think it is a very impressive statue. I am able to see it when I leave work. I think it captures the American soldier's ideals."

"The Infantryman" is an outstanding symbol of freedom," said 1st Lt. Tom Strehle, Headquarters and Headquarters Company, Berlin Brigade.

"I see the statue from the back every evening and I often wonder how often his hand hits his entrenching tool when he comes to parade rest," joked Capt. Duncan Turner. "Seriously, I bring many visitors through this building and they are very impressed with the 'Doughboy.'"

"To me, he represents today's infantryman, Pvt. 2 Clifford J. Smith, Company C, 3rd Batt "Standing straight and tall, his integrity, co

PLAQUE INSCRIPTION

This Bronze Life-Sized Statue of an American Infantryman was Created by Herr Ernst Kunst of Berlin. The original, made of Plaster, was presented to the Commanding General of the Berlin District in 1946 to commemorate the 171st Anniversary of the United States Infantry.

Staff Sergeant Thomas E. Love, a combat veteran of World War II stationed in Berlin was selected as the model.

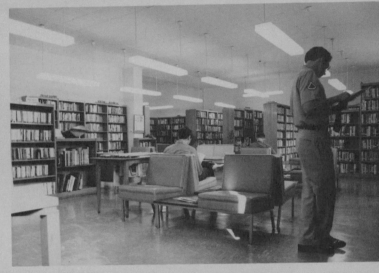

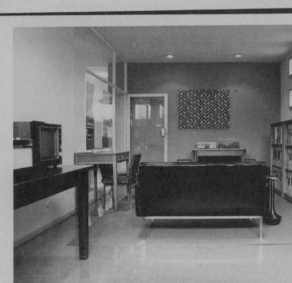

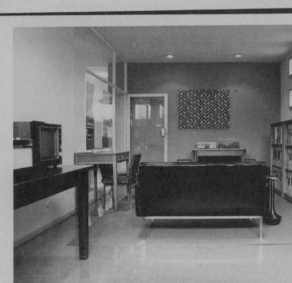

an agreement with the wife's attorney.

If the soldier is seeking a divorce, the legal officer can advise him on grounds for divorce, where to file the divorce, and how to begin divorce proceedings.

The main thing to remember is, if you think you need help, ask.

—AFPS

THE BERLIN OBSERVER

0, No. 2 **U. S. ARMY, BERLIN** January 18, 1974

Commander, Berlin MG Wm. W. Cobb
ander, Berlin Brigade BG Robert D. Stevenson
Affairs Officer LTC W. B. Gard
nation Services Officer 1LT John J. Spiezia
and Information NCO SSG Herbert D. Sharp

BERLIN OBSERVER is an authorized, unofficial, letterpress aper published under the provisions of AR 360-81. It is under vision of the Information Services Branch, Public Affairs, Office U. S. Commander, Berlin and is published weekly for personnel U. S. Army, Berlin, and Berlin Brigade. Except for copyrighted dicated material, all items may be reprinted without further ance. Contributions are solicited from readers but publication ds upon the judgment of the editor. Deadline for submission of is Wednesday. No payment will be made for contributions. and opinions expressed herein are not necessarily those of the rtment of the Army. Editorial office is located in Rm. 1124, 2, Headquarters Compound.

ess correspondence to THE BERLIN OBSERVER, Public Affairs e of the U. S. Commander, Berlin, APO 09742. Telephone: (238) 2/6112.

ed by Chmielorz, Berlin-Neukoelln, Phone 623 30 45.

EDITORIAL STAFF

itors .. SP5 Lucas C. Hutton
 SP4 V. A. Drosdik, III
rters .. SP4 Michael McCollum
 SP4 Joseph R. Bolduc
grapher .. SP4 Richard A. Bailey
ral Events .. Helga Haftendorn

BATTALION CORRESPONDENTS

al Troops, tel. 3581 SP5 Gary G. Newman
3n, 6th Inf, 3201/3225 SGT Faustino De La Cruz
3n, 6th Inf, 3320 SGT Ralph Callaway
, 6th Inf, 3250 SP4 Norman G. Ham

library notes Marga Danesy

Crump Hall Library begins exhibitions

Displays and books are a natural combination. Each represents a means of spreading knowledge and exciting interest, books through word symbols, and displays through visual symbols.

With the new year we have an added feature at the Crump Hall Library: every two months we will focus on an exhibition of paintings, drawings, photographs, prints, local museum material, collections of insects, stamps, coins, stones or works of arts and crafts.

Our January/February display of paintings has been graciously lent to us by Mrs. Horton, art teacher at the John F. Kennedy School, and her students. In the near future we plan a neighborhood exhibition of your works of art. Everyone who has painting or drawing abilities is welcome to exhibit his work of art with us. If you have never tried your hand at art work, why don't you give yourself a chance? You might discover a hidden talent! Books for beginners and advanced hobby artists are available at your Special Services Libraries.

We would also appreciate knowing which collectors would let us display their items for a short period of time. Our utmost care is guaranteed. If you are interested in displaying your paintings, drawings, photographs or collections, please contact Marga Danesy, program chairman at the main library, at Berlin military 6119.

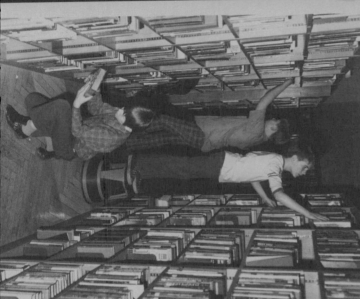

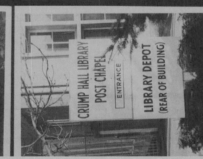

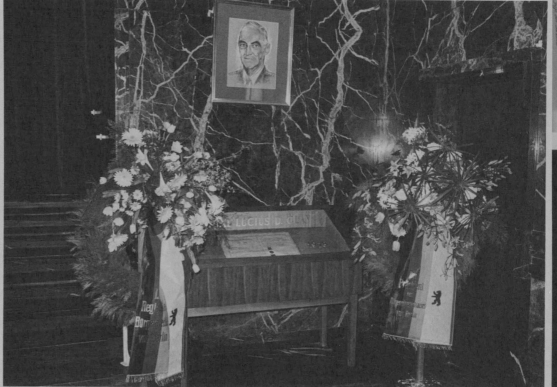

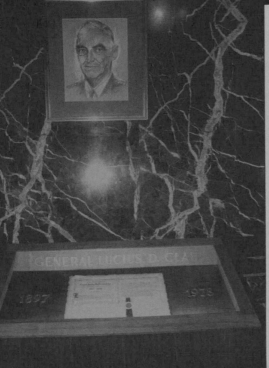

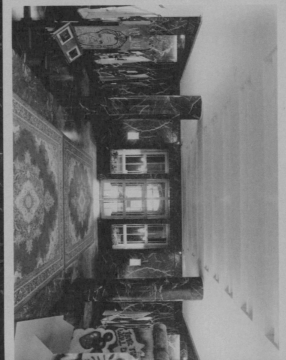

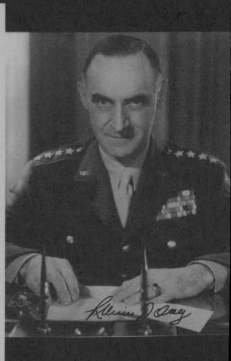

In Appreciation

o: General

Lucius D. Clay

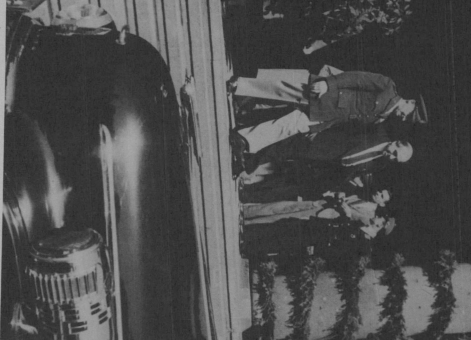

Br 146 → 62 mm
26" 141 → 60 mm

42 %

S. 26

Stephan Trüby
Death and Taboos—On Architectures from the Era
of National Socialism and their Conversion Decorum

As the last witnesses of National Socialism pass away, we are
seeing vehement ongoing debates comparable in intensity to
the Historikerstreit (historians' dispute) of the 1980s. This dis-
pute revolved around the relationship between National
Socialism and communism; today, in the course of the cur-
rently developing "Historikerstreit 2.0," it is directed at the
differences and overlaps between anti-Semitism and racism
and between the Holocaust and colonialism in the present
context of an increasingly diverse society.[1] Today, there is
also a debate raging over "far-right spaces," which concerns
the extent to which contemporary right-wing populist move-
ments employ architecture and urban planning in pursuit of a
nationalist identity agenda.[2] This is complemented by a
patchwork of individual discussions that address the various
architectural remnants of National Socialism and the central
questions of their use and conversion. The following is a com-
parative take on these individual debates. The loss of National
Socialism's contemporaneous witnesses and society's in-
creasing diversification seem to go hand in hand with an in-
tensification of debates regarding the narrative power of
architectures and urban spaces—especially when consider-
ing that Adolf Hitler himself coined the phrase "word made of
stone."[3]

But what exactly is National Socialism's architectural
legacy? More specifically, what is "Nazi architecture," and
how much of it is there? Are there three National Socialist
architectural styles, as asserted by Joachim Petsch, who dis-
tinguishes between heroic classical state and party architect-
ure, so-called Heimatschutzstil (Homeland Protection Style),
and the Neue Sachlichkeit (New Objectivity) style of factories
and bridges?[4] Are there four varieties of architecture under
National Socialism, as Norbert Borrmann aimed to establish
by differentiating between "representative buildings—
Classicism; Ordensburgen (religious castles), memorials—
Romanesque style; housing, rural buildings—Heimatschutz-
stil; industrial buildings—Modernism"?[5] Or are there even,
as Helmut Weihsmann has concluded, six architectural
tendencies in National Socialism: Classicism for propaganda,
state, and party buildings; Heimatschutzstil architecture for
housing estates and Ordensburgen; moderate Modernism
for residential and administrative buildings; Pathetischer
Funktionalismus (sentimental functionalism)[6] for barracks,
army buildings, and industrial administration buildings;
revised Functionalism for sports buildings and stadiums;
and New Objectivity for technical, industrial, and factory
buildings?[7] And what about the camps and their barracks
architecture? Why is it, at least beyond Holocaust research,
that they were so often overlooked in the standard taxonomies
of architecture under National Socialism? Politically moti-
vated disregard can hardly be the reason, with the exception
of Borrmann, whose scholarly reputation has been tarnished
since his extreme right-wing political stance became known.[8]
In order to answer the question regarding the number of
architectural categories under National Socialism, a shift in
perception from the perpetrator's perspective toward that of

Stephan Trüby
Tote und Tabus – Über Architekturen aus der Zeit des
Nationalsozialismus und ihr Umnutzungsdecorum

Die Zeit des Aussterbens von Zeitzeug*innen des National-
sozialismus wird begleitet von vehementen Debatten, die an
Schärfe hinter dem Historikerstreit der 1980er Jahre nicht zu-
rückstehen. Damals wurde um das Verhältnis von National-
sozialismus und Kommunismus gestritten, heute, im Zuge
des „Historikerstreits 2.0", geht es um die Unterschiede und
Schnittmengen von Antisemitismus und Rassismus, von Ho-
locaust und Kolonialismus im Kontext einer zunehmend di-
vers werdenden Gesellschaft.[1] Gleichzeitig tobt eine Debat-
te um „Rechte Räume", in der die Frage verhandelt wird,
inwieweit rechtspopulistische Bewegungen der Gegenwart
Architektur und Städtebau gezielt für eine nationalistische
Identitätsagenda einsetzen.[2] Dazu kommt ein Flickenteppich
aus Einzeldiskussionen über eine ganze Reihe von gebauten
Hinterlassenschaften des Nationalsozialismus, bei denen
Nutzungs- beziehungsweise Umnutzungsfragen im Zentrum
stehen. Im Folgenden sei ein komparativer Blick auf diese in-
dividuellen Debatten geworfen. Sowohl das Aussterben von
Zeitzeug*innen des Nationalsozialismus als auch die zuneh-
mende Diversifizierung der Gesellschaft gehen, so scheint
es, mit einer Intensivierung der Auseinandersetzungen darü-
ber einher, inwieweit Architekturen und Stadträume über
eine eigene Erzählkraft verfügen; zumal Adolf Hitler selbst
die Rede von „Worten aus Stein" geprägt hat.[3]

Doch was genau sind die gebauten Hinterlassenschaften
des Nationalsozialismus? Pointierter gefragt: Was ist „Nazi-
Architektur" – und wenn ja, wie viele? Gibt es drei Architek-
turrichtungen des Nationalsozialismus, wie Joachim Petsch
mit seiner Unterscheidung von heroisch-klassizistischer
Staats- und Parteiarchitektur, Heimatschutzstil und dem
sachlichen Baustil der Fabriken und Brücken meint?[4] Gibt es
vier Spielarten der Architektur im Nationalsozialismus, wie
Norbert Borrmann mit der Differenzierung „Repräsentative
Bauten – Klassizismus; Ordensburgen, Gedenkstätten – Ro-
manik; Wohnungsbau, ländliche Bauten – Heimatstil; Indust-
riebau – Moderne"[5] ausdrücken will? Gibt es gar, wie Helmut
Weihsmann konstatiert, sechs Tendenzen der Architektur im
Nationalsozialismus, nämlich Klassizismus für Propaganda-,
Staats- und Parteibauten, Heimatschutzstil für Siedlungs-
bauten und Ordensburgen, moderate Moderne für Wohn-
und Verwaltungsbauten, pathetischer Funktionalismus für
Kasernen, Heeresbauten und Industrieverwaltungsbauten,
versachlichter Funktionalismus für Sportbauten und Stadien,
und die Neue Sachlichkeit für Technik-, Industrie- und Fabrik-
bauten?[6] Und was ist dann mit der Baracken-Architektur der
Lager? Warum wird diese, jedenfalls jenseits der Holocaust-
forschung, in den gängigen Taxonomien von Architektur im
Nationalsozialismus so oft unterschlagen? An politisch mo-
tivierter Dethematisierung kann es kaum liegen, sieht man
mal von Borrmann ab, dessen wissenschaftliche Reputation
seit Bekanntwerden seiner politisch extrem rechts zu veror-
tenden Haltung entwertet ist.[7] Um die Frage nach der Anzahl
von Architekturkategorien im Nationalsozialismus zu beant-
worten, sei im Folgenden eine Wahrnehmungsverschiebung
weg von der Täter*innen- hin zur Opferperspektive vorge-

the victim is performed in the following essay, primarily by taking into account the current debates surrounding use and conversion. Approximately eighty to ninety years after the creation of the National Socialist era's buildings, the question today is: Which (re)uses of which building types are prone to allergic reactions in the public perception? And what gets the nod of approval without objection?

Addressing these issues will require talking about the dead and about taboos. Considered from the perspective of (re)use, six architectural categories emerge, as with Weihsmann. Unlike his categorization, however, this essay elides the distinctions of Classicism, moderate Modernism, and Pathetischer Funktionalismus for state and administrative buildings of various uses, as well as those of revised Functionalism and New Objectivity for sports and industrial buildings, which were hard to maintain in the first place. Instead, two new categories open up: the "political theology" of state ceremonial, party conference, and representative buildings in Munich, Nuremberg, and elsewhere; and then—as the "flipside of the coin"—constructions for the condemned in the labor, concentration, and extermination camps.

From the perspective of the National Socialist protagonists, these two categories were incompatible extremes. From a present-day perspective with a focus on reconversion, however, they suddenly share proximity with one another, with both continuously regarded as difficult if not impossible to repurpose for reasons of decorum and respect. A systemization of National Socialist architecture is presented below against this background, outlining a spectrum of reuse with two opposing ends. One being: "further use identical to the original purpose possible without problems"; the other: "conversion or even further use completely out of the question." Residential buildings constructed in the spirit of Heimatschutz or "blood and soil" ideology are addressed first, followed by state and administrative architecture without "party liturgical" functions;[9] industrial buildings in the spirit of modern Functionalist architecture; massive concrete bunker buildings for civil defense; and, finally, the two "highest" categories in the "conversion impossible" scale: Nazi cult architecture on the one hand and the camps on the other.

There was no normative National Socialist architectural theory formulated a priori. There was, however, a gradual *poiesis*, which, from the viewpoint of the responsible protagonists, cannot be denied a certain terrible consistency in retrospect. To date, only a scattered history of the practice in these *poietically* fabricated spaces exists, which has been carried on for decades and is at times accompanied by great emotionality. A presentation of this "collective practice," at least in its outlines, is the goal of the following remarks.

1. Residential Buildings Conformable to Heimatschutz Architecture and Informed by "Blood and Soil"

According to popular opinion, residential architecture from the National Socialist era is a building genre that can be utilized for identical purposes without any problems. This is likely due primarily to the fact that it predominantly represented a variant of the conservative Heimatschutz architecture, which was already established in the first two decades of the twentieth century and is associated with names such as Paul

nommen, und zwar indem die aktuellen Nutzungs- und Umnutzungsdebatten in die Kategorisierungserwägungen mit hineingenommen werden. Rund achtzig bis neunzig Jahre nach der Entstehung aller Bauten aus der Zeit des Nationalsozialismus ist heute zu fragen: Welche (Um-)Nutzungen welcher Gebäudetypen neigen zu allergischen Reaktionen in der öffentlichen Wahrnehmung? Was wird problemlos goutiert?

Um diesen Fragen näherzukommen, wird über Tote und Tabus zu sprechen sein. Unter Einbeziehung der (Um-)Nutzungsperspektive konturieren sich – wie schon bei Weihsmann – ebenfalls sechs Kategorien, nur verschmelzen hierbei erstens die ohnehin kaum aufrecht zu erhaltenden Weihsmann'schen Distinktionen von Klassizismus, moderater Moderne und pathetischem Funktionalismus – für Staats- und Verwaltungsbauten diverser Nutzungsarten – sowie versachlichtem Funktionalismus und der Neuen Sachlichkeit – für Sport- und Industriebauen. Stattdessen tun sich zwei neue Kategorien auf: einmal die „politische Theologie"[8] staatlicher Feierlichkeits-, Parteitags- und Repräsentationsbauten in München, Nürnberg und anderswo; und dann – als „Kehrseite der Medaille" – die Bauten für die Todgeweihten in den Arbeits-, Konzentrations- und Vernichtungslagern. Beide Kategorien wurden aus der Perspektive nationalsozialistischer Akteur*innen als ultimative Extrempole betrachtet, doch rücken sie in der Umnutzungsperspektive der Gegenwart plötzlich nahe zusammen: Bis heute gelten sie aus Schicklichkeits- und Pietätsgründen nur schwer bis unmöglich umnutzbar. Im Folgenden sei vor diesem Hintergrund eine Ordnung der NS-Architektur vorgestellt, die ihre Extrempunkte in „problemlos zweckidentisch weiter nutzbar" und „Um- oder Weiternutzung völlig ausgeschlossen" findet. Sie beginnt mit Wohnbauten, die im Geiste des Heimatschutzes bzw. der „Blut-und-Boden"-Ideologie gebaut wurden; es folgen staatliche Repräsentations- und Verwaltungsarchitekturen ohne parteiliturgische Funktionen; des Weiteren Industriebauten im Geiste modern-funktionalistischer Architektur; dann massive Beton-Bunkerbauten für den Zivilschutz. Als die beiden „höchsten" Kategorien in der „Umnutzung unmöglich"-Skala folgen schließlich die Architekturen von NS-Kulten einerseits und der Lager andererseits.

Es gibt keine konzertierte normative Architekturtheorie des Nationalsozialismus, die *a priori* formuliert worden wäre – aber eine nach und nach präzisierte Poiesis, der man aus Sicht der verantwortlichen Akteur*innen im Nachhinein eine gewisse schreckliche Konsistenz nicht absprechen kann. Und es gibt eine bis dato nur versprengt vorliegende Geschichte der Praxis in diesen poietisch verfertigten Räumen, die seit Jahrzehnten betrieben und bisweilen von größter Emotionalität begleitet wird. Diese kollektive Praxis zumindest in ihren Grundzügen darzulegen, sei als Ziel für die folgenden Äußerungen gesteckt.

1. Wohnhäuser gemäß einer zu „Blut und Boden" verschärften Heimatschutzarchitektur

Die Wohnarchitektur aus der Zeit des Nationalsozialismus ist als diejenige Baugattung zu betrachten, die – Ausnahmen bestätigen die Regel – nach verbreiteter Meinung völlig problemlos zweckidentisch weiterverwendet werden kann. Dies liegt sicherlich vor allem daran, dass sie zumeist

Schmitthenner (1884–1972). Schmitthenner's work is synonymous with this architectural style that was aimed at overcoming in particular Historicism and Art Nouveau during the Weimar Republic and at counteracting Neues Bauen (New Building) by referencing local and regional traditions—albeit getting quickly tied up with nationalist tendencies à la "Deutsches Haus." Under National Socialism, Heimatschutz architecture, characterized by pitched roofs and a traditional appearance, was ideologically transmuted into blood-and-soil architecture—this did not require major formal aesthetic changes, apart from applying the occasional swastika or *Wolfsangel* (wolf's hook) ornament from 1933 onwards. In the field of domestic buildings, the bourgeois house dominated above all during the National Socialist era—often grouped together to form settlements, which would also become the spatial instrument for "Germanizing" the "living space in the East" after 1939. Schmitthenner erected paradigmatic buildings for both forms of housing, such as the Kochenhofsiedlung in Stuttgart [Fig.1], presented in 1933 as a counterdesign to the Weißenhofsiedlung in the context of the building exhibition *Deutsches Holz für Hausbau und Wohnung* (German Wood for House Construction and Housing); and the Haus Werner, a villa for the mechanical engineering manufacturer Otto Werner, completed in the same city in 1936 [Fig.2]. Whenever houses like this are demolished, in the case of Haus Werner in Berlin as recently as 2021, it is almost always for economic or aesthetic reasons—in any case for non-political motives.[10] This is true even when—as was the case following the demolition of the Haus Köster in Stuttgart in 2019, which had been built by Schmitthenner from 1936 to 1937—the owner is indirectly quoted that he does not understand the fuss, "especially seeing that Schmitthenner was a National Socialist."[11]

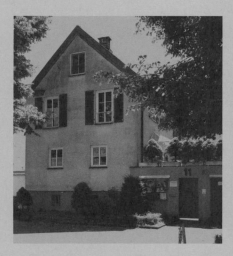

1

The hundreds of thousands, if not millions, of residential buildings erected during National Socialism are still in use today without much ado. Disruptions motivated by a sense of decorum occur almost exclusively with respect to the houses of the Nazi leadership elite, such as the remains of the Berghof in the former "Führer's Restricted Area Obersalzberg," Hitler's private residence from 1936 on. The house, which was converted into a representative alpine residence with a large

eine Variante der konservativen Heimatschutzarchitektur darstellte, die bereits in den ersten beiden Jahrzehnten des 20. Jahrhunderts sich zu etablieren vermochte und mit Namen wie Paul Schmitthenner (1884-1972) verbunden ist. Dessen Architektur steht für eine Bauweise, mit der bereits in der Weimarer Republik insbesondere Historismus und Jugendstil überwunden und das Neue Bauen durch Bezugnahmen auf lokale und regionale Traditionen konterkariert werden sollten – die aber schnell in nationalistische Fahrwasser à la „Deutsches Haus" gerieten. Im Nationalsozialismus wurde die Heimatschutzarchitektur, die durch Steildächer und ein traditionelles Erscheinungsbild geprägt ist, ideologisch zwar zur „Blut-und-Boden"-Architektur verschärft – was formalästhetisch aber kaum zu Veränderungen führen musste, wenn man von dem einen oder anderen ab 1933 angebrachten Hakenkreuz- oder Wolfsanker-Ornament absieht. Im Bereich des domestischen Bauens dominiert in der Zeit des Nationalsozialismus vor allem das bürgerliche Haus – oftmals gruppiert zur Siedlung, die nach 1939 auch zum Raumgreifungsinstrument einer „Germanisierung" des „Lebensraums im Osten" werden sollte. Schmitthenner errichtete für beide Wohnformen paradigmatische Bauten, so die 1933 im Rahmen der Bauausstellung *Deutsches Holz für Hausbau und Wohnung* als Gegenentwurf zur Weißenhofsiedlung präsentierte Kochenhofsiedlung in Stuttgart [Abb.1]; so auch in derselben Stadt das Haus Werner, die 1936 fertiggestellte Villa des Maschinenbaufabrikanten Otto Werner [Abb.2]. Wenn derlei Häuser abgerissen werden – und beim Haus Werner droht derzeit der Abriss[9] –, so fast immer aus ökonomischen oder ästhetischen, jedenfalls nicht-politischen Gründen. Auch dann, wenn – wie nach dem 2019 erfolgten Abriss den von Schmitthenner in den Jahren 1936 bis 1937 errichtetem Haus Köster in Stuttgart geschehen – der Besitzer indirekt mit den Worten zitiert wird, dass er die Aufregung nicht verstehe, „zumal Schmitthenner Nationalsozialist war".[10]

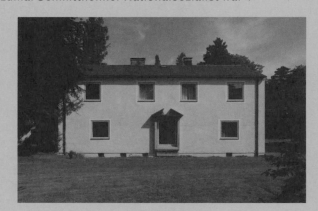

2

Die in die Hunderttausende, wenn nicht Millionen gehende Zahl an Wohngebäuden, die im Nationalsozialismus errichtet wurden, sind bis heute ohne viel Aufhebens weiter in Benutzung. Schicklichkeits-motivierte Nutzungsbrüche hingegen entstehen dort fast nur bei Häusern der NS-Führungselite, so etwa bei den Resten des Berghofs im ehemaligen „Führersperrgebiet Obersalzberg", Hitlers privatem Wohnsitz ab 1936. Das Haus, das im selben Jahr von Roderich Fick zu einer repräsentativen Alpenresidenz mit großem Saal

hall including panoramic windows in the same year by Roderich Fick, was severely damaged in an Allied air raid in 1945 and then returned to the Free State of Bavaria by the US in 1951 on the condition that the ruins be completely demolished. After the remains of the building were blown up in 1952, the site was demonstratively reforested—which does not stop tourists from all over the world from buying Hitler memorabilia, taken from the few remaining fragments still in existence [Fig. 3].[12]

The residential architecture of the Nazi elite—when it hasn't been completely destroyed—is constantly at risk of right-wing appropriation, as illustrated by the example of Joseph Goebbels' country residence at Bogensee lake in Brandenburg, which was built by Hugo Constantin Bartels in 1939 and based on a design by Heinrich Schweitzer. Undamaged during the Second World War, it was converted into the Free German Youth's school in the Soviet occupation zone and later extended with a building in the style of Socialist Classicism by Hermann Henselmann in the German Democratic Republic (GDR). After German reunification, the site became the property of the State of Berlin and has been awaiting a new designation ever since [Fig. 4]. In 2020, an initiative of about twenty people called Leben und Kreativ Campus Bogensee (Life and Creativity Campus Bogensee or LKC) was founded, calling for a colorful mix of housing, theater, yoga, and workshops on the sprawling site and a museum dedicated to the topic of "totalitarianism" created in Goebbels' house itself. In August 2021, however, news broke that members of the far-right Reichsbürger organization Königreich Deutschland (Kingdom of Germany), which centers around Peter Fitzek, had infiltrated the initiative. According to a media report, actor and director Armin Beutel, chairman of the LKC association, "ruled out further cooperation with the exposed Reichsbürgers and announced the examination of expulsion proceedings."[13]

2. State and Administrative Architecture Conformable to a (Sometimes Classical) Architectural Schematism

State and administrative architecture comprises a second building type, discussed here in terms of its potential for further use and reconversion. This identifiable variant generally has a tendency towards the monumental, its appearance varying between "antique-like" and "schematic-like"—manifesting not just strictly as one or the other, but also as a mixture of both. The latter is represented, for example, by Paul Ludwig Troost's buildings on Königsplatz in Munich, erected between 1933 and 1937 as stone-clad steel structures, including the administrative building of the NSDAP and the Führerbau (Führer building), which housed the offices of Hitler and his deputies. Both buildings are characterized by a strong reduction of construction elements, oscillating between "holy earnestness"—some might say "hollow pathos"—and banal schematism. While the layered motif on the façade emphasizes the walls, a classical support and entablature motif appears on the inside: in the Führerbau, the courtyard is surrounded by columns; in the party's administrative building, by supports on a square ground plan [Fig. 5]. Both buildings remained largely intact, having resisted the destruction of the Second World War to become the US mili-

samt Panoramafenster umgebaut wurde, ist 1945 bei einem alliierten Luftangriff schwer beschädigt und von den US-Amerikanern im Jahre 1951 dem Freistaat Bayern unter der Bedingung, die Ruinen des Hofes komplett abzureißen, zurückgegeben worden. Nach der 1952 erfolgten Sprengung der Gebäudereste wurde das Gelände demonstrativ aufgeforstet – was aber bis heute Tourist*innen aus aller Welt nicht davon abhält, sich an den wenigen verbliebenen Mauerresten mit Hitler-Devotionalien zu versorgen [Abb. 3].[11]

Dass Wohnarchitekturen von NS-Eliten, sofern sie nicht komplett zerstört wurden, ständig von rechten Vereinnahmungen bedroht sind, zeigt das Beispiel von Joseph Goebbels' Landsitz am Bogensee in Brandenburg, das nach einem Entwurf von Heinrich Schweitzer von Hugo Constantin Bartels 1939 errichtet wurde. Im Zweiten Weltkrieg unbeschädigt, wurde es zunächst in der sowjetischen Besatzungszone zur Zentralschule der Freien Deutschen Jugend umfunktioniert und später in der DDR mit einem Bau von Hermann Henselmann im Stil des Sozialistischen Klassizismus erweitert. Nach der Wende fiel das Gelände in den Besitz des Landes Berlin und harrt seither einer neuen Nutzung [Abb. 4]. Zwar hat sich 2020 die rund zwanzigköpfige Initiative Leben und Kreativ Campus Bogensee (LKC) gegründet, die sich auf dem weitläufigen Areal einen bunten Mix aus Wohnen, Theater, Yoga und Werkstätten wünscht und im Goebbels-Haus selbst ein Museum zum Thema „Totalitarismus" einrichten will. Im August 2021 wurde bekannt, dass Mitglieder der Reichsbürger-Organisation Königreich Deutschland um Peter Fitzek die Initiative unterwandert hätten. Einem Medienbericht zufolge schließt der Schauspieler und Regisseur Armin Beutel, Vorsitzender des Fördervereins LKC, „eine weitere Zusammenarbeit mit den enttarnten Reichsbürgern aus und kündigte die Prüfung von Ausschlussverfahren an".[12]

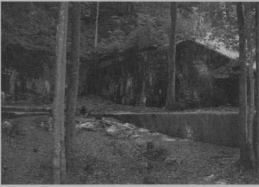

3

4

tary government's central collecting point for art looted by the Nazis throughout Europe during the war. The former Führerbau was later occupied by the Amerika Haus before it relocated into its own building. The congress hall, which had been under construction, was converted into a concert hall in 1957 when the Hochschule für Musik und Theater (University of Music and Performing Arts) moved in. The administration building is now home to the Zentralinstitut für Kunstgeschichte (Central Institute for Art History). These two examples, to which many more could be added, illustrate how the monumentalism of Nazi architecture, oscillating between bureaucratic banality and pompous style, can for the most part continue to be utilized without outrage, provided it was not destroyed in the war.

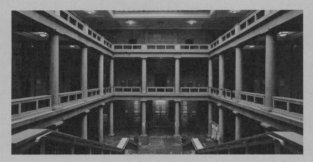

5

Although the few underground remains of Albert Speer's Neue Reichskanzlei (New Reich Chancellery) in Berlin are today publicly tabooed and have become a destination for "dark tourism," other significant Nazi government buildings were repurposed without much ado. This is particularly true of those that, while avoiding overly classical column elements, are characterized by a bureaucratic appearance in the sense of Pathetischer Funktionalismus. The extension building of the Reichsbank in Berlin can serve as an example: built between 1934 and 1940 by Heinrich Wolff, it became East Germany's Ministry of Finance in 1949 and the seat of the Socialist Party's Central Committee in 1959. Following a renovation by Hans Kollhoff, the building is now called Haus am Werderschen Markt 1 and houses the Federal Foreign Office since 1999. Likewise, the Berlin Reich Ministry for Public Enlightenment and Propaganda, headed by Joseph Goebbels and built from 1938 to 1939 by Karl Reichle, was partially destroyed during the war but later repaired in the GDR and used by the National Front of the German Democratic Republic as the seat of the National Council. After German reunification, the Federal Environment Agency was initially housed there, before later becoming the Federal Ministry of Labor and Social Affairs following the conversion and addition of a building extension by Josef Paul Kleihues and his son Jan Kleihues in the year 2000 [Fig. 6]. The latter example's Pathetischer Funktionalismus finds its model in the Reich Ministry of Aviation, built between 1935 and 1936, based on plans by Ernst Sagebiel: a reinforced concrete skeleton building with a flat roof that appears thoroughly modern despite its stone cladding. For this reason, the style is also referred to as "Luftwaffe Modernism."[14] During the GDR the building served as the House of Ministries and became the headquarters of the Treuhandanstalt in the 1990s. Since 1992, it has carried the

2. Staatliche Regierungs– und Verwaltungsarchitektur gemäß eines (manchmal antikisierend-klassierend anmutenden) Architektur-Schematismus

Eine zweite Gebäudegattung, die hinsichtlich ihrer Weiternutzungs- und Umnutzungspotenziale angesprochen sei, ist die staatliche Regierungs- und Verwaltungsarchitektur. Sie hat allgemein eine Tendenz ins Monumentale und kann sowohl in den Spielarten „antikisierend" oder „schematisch anmutend" auftreten – aber auch in Mischformen davon. Für Letztere stehen etwa die zwischen 1933 und 1937 als steinverkleidete Stahlkonstruktionen errichteten Bauten Paul Ludwigs Troosts am Königsplatz in München, also der „Verwaltungsbau der NSDAP" und der „Führerbau", in dem sich auch Hitlers Büro und die Arbeitsräume seiner Stellvertreter befanden. Beide Bauwerke sind durch eine starke Reduktion der Bauelemente gekennzeichnet, die zwischen heiligem Ernst – manche sagen: hohlem Pathos – und banalem Schematismus changiert. Während an der Fassade durch das Schichtungsmotiv die Wandhaftigkeit betont wird, taucht im Inneren ein klassizierend anmutendes Stütz- und Gebälkmotiv auf: Im „Führerbau" wird der Hof von Säulen umstellt, im Verwaltungsbau von Stützen auf quadratischem Grundriss [Abb. 5]. Beide Bauten blieben im Zweiten Weltkrieg weitgehend unzerstört und wurden nach 1945 zum „Central Collecting Point" der US-Militärregierung für die während des Zweiten Weltkriegs von den Nazis in ganz Europa zusammengeraubte Beutekunst. In den ehemaligen „Führerbau" zog später das Amerikahaus ein, bevor es ein eigenes Gebäude erhielt. Der sich einst im Bau befindliche Kongresssaal wurde 1957, als die sich noch heute darin befindende Hochschule für Musik und Theater einzog, zu einem Konzertsaal umfunktioniert. Im „Verwaltungsbau" ist heute das Zentralinstitut für Kunstgeschichte angesiedelt. Die beiden Beispiele, die durch viele weitere ergänzt werden könnten, zeigen, dass der zwischen Bürokratie-Banalität und hohem Ton changierende Monumentalismus der NS-Architektur, sofern er nicht im Krieg zerstört wurde, zumeist empörungslos weiter nutzbar ist.

Wenngleich die wenigen unterirdischen Reste der 1935 bis 1943 von Albert Speer erbauten, 1945 schwer beschädigten und 1949 dann weitgehend beseitigten Berliner Neuen Reichskanzlei bis heute stark tabuisiert und zur „dark tourism"-Destination wurden, sind andere signifikante NS-Regierungsbauten umstandslos anderen Nutzungen zugeführt worden. Insbesondere jene, die unter Vermeidung allzu klassierender Säulenelemente von einem bürokratischen Erscheinungsbild im Sinne eines „pathetischen Funktionalismus"[13] geprägt sind. So etwa der 1934 bis 1940 durch Heinrich Wolff errichtete Erweiterungsbau der Reichsbank in Berlin, der 1949 zum Finanzministerium der DDR und 1959 zum Sitz des Zentralkomitees der SED wurde. Seit 1999, seit einer Sanierung durch Hans Kollhoff, bildet das nun Haus am Werderschen Markt 1 genannte Bauwerk zusammen mit dem Neubau des Ministeriums, errichtet 1997 bis 1999 von Thomas Müller Ivan Reimann Architekten, den Hauptsitz des Auswärtigen Amts; ebenso das 1938 bis 1939 durch Karl Reichle errichtete Berliner Reichsministerium für Volksaufklärung und Propaganda unter Führung von Joseph Goebbels, das im Krieg teilweise zerstört, in der DDR wieder aufgebaut sowie von der Nationalen Front der DDR als Sitz des Zentralrats genutzt wurde. Seit der

name Detlev-Rohwedder-Haus in memory of the Treuhand president's 1991 assassination. Since 1999, it has been the seat of the Federal Ministry of Finance. "Luftwaffe Modernism" is also variously present in numerous Luftgaukommandos—*including* the Berlin Luftgaukommando III, which was built from 1936 to 1938 and based on plans by Fritz Fuß—and the residential buildings for the air force staff, concurrently built by Sagebiel. After the Second World War, the site was confiscated by the US Army to house the headquarters of the US military governor. The historic site, which was also used to organize the Berlin Airlift in 1948/49, today serves multiple uses: after extensive renovation, part of the premises now house the US Consulate; another part mutated into the condominium complex known as The Metropolitan Gardens, which is comprised of 290 apartments and business suites; while the main building with its magnificent marble-clad foyer on the ground floor and the so-called Kennedy Hall above is now owned by entrepreneur and art collector Markus Hannebauer, who had Berlin architectural firm Sauerbruch Hutton convert the premises into living quarters with integrated, publicly accessible museum spaces for his media art collection Fluentum.

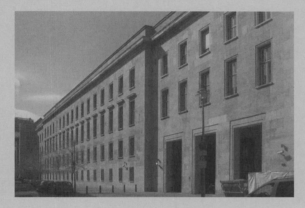

6

3. Airport and Industrial Buildings Conformable to (Sometimes Melodramatically Stone-Clad) Architectural Modernism

Similar to most of the residential and administrative architecture, Nazi-era airport and industrial buildings can be used or converted relatively without much difficulty—perhaps because these buildings maintained a certain continuity with modern architecture from 1933 to 1945. This can be seen, for example, in the case of Berlin's Tempelhof Airport, which in 1935 was converted by Sagebiel into a major modern airport for up to six million travelers a year per the commission by the Reich Aviation Ministry. Behind a strictly gridded façade, extensively clad with natural slabs of shelly limestone, the interior—such as the check-in hall—unfolds in what from today's perspective is a thoroughly revolutionary approach to functional complexity, including level separations. The adjacent round hangar with a cantilevered roof faces the airfield and is covered by a steel construction of over forty meters in height, providing sufficient space for aircrafts up to twelve meters in height—at least until 2008, when the airport ended operations presumably for good. Since then, interim use has alternated with high frequency: ice hockey events, equestrian

Wiedervereinigung war dort zunächst das Umweltbundesamt, seit der späteren Ergänzung eines Um- und Erweiterungsbaus durch Josef Paul Kleihues sowie dessen Sohn Jan Kleihues ist hier seit 2000 das Bundesministerium für Arbeit und Soziales untergebracht [Abb. 6]. Der „pathetische Funktionalismus" der zuletzt erwähnten Beispiele findet sein Vorbild im 1935 bis 1936 nach Plänen Ernst Sagebiels errichteten Berliner Reichsluftfahrtministerium, einem trotz Steinverkleidung durchaus modern wirkenden Stahlbetonskelettbau mit Fachdach. Man spricht daher auch von der „Luftwaffen-Moderne".[14] Der Bau diente zu DDR-Zeiten als Haus der Ministerien und wurde in den 1990er Jahren zum Sitz der Zentrale der Treuhandanstalt. Seit 1992 trägt es im Gedenken an die 1991 erfolgte Ermordung des Treuhand-Präsidenten den Namen Detlev-Rohwedder-Haus und ist seit 1999 Sitz des Bundesministeriums der Finanzen. Die „Luftwaffen-Moderne" liegt variantenreich auch in diversen Luftgaukommandos vor – so etwa im Berliner Luftgaukommando III, das 1936 bis 1938 nach Plänen von Fritz Fuß errichtet wurde – die Wohngebäude für die Bediensteten der Luftwaffe errichtet parallel Sagebiel. Nach dem Zweiten Weltkrieg wurde die Anlage von der US-Armee beschlagnahmt, um dort den Sitz des US-amerikanischen Militärgouverneurs einzurichten. Auf dem geschichtsträchtigen Grund, auf dem 1948/49 auch die Berliner Luftbrücke organisiert wurde, befindet sich heute ein Mix verschiedener Nutzungen: Nach einer umfassenden Sanierung wird ein Teil des Geländes als US-Generalkonsulat genutzt, ein anderer mutierte zur Eigentumswohnanlage The Metropolitan Gardens mit 290 Wohnungen und Business-Suiten. Das Hauptgebäude mit seinem prächtigen, marmorbekleideten Foyer im Erdgeschoss und dem darüberliegenden „Kennedysaal" befindet sich heute im Besitz des Unternehmers und Sammlers Markus Hannebauer, der die Räumlichkeiten vom Berliner Architekturbüro Sauerbruch Hutton zu Wohnräumen mit integrierten, öffentlich zugänglichen Museumsräumen für seine Medienkunstsammlung Fluentum ausbauen ließ.

3. Flughafen- und Industriebauten gemäß einer (manchmal pathetisch steinverkleideten) Architekturmoderne

Ähnlich problemlos wie der Großteil der Wohn- und Verwaltungsarchitektur sind die Flughafen- und Industriebauten der NS-Zeit weiter nutzbar bzw. umnutzbar – was vielleicht auch der Tatsache geschuldet ist, dass sich hier gewisse Kontinuitäten moderner Architektur auch während der Jahre 1933 bis 1945 erhalten haben. Das sieht man etwa am Beispiel des Berliner Flughafens Tempelhof, der ab 1935 im Auftrag des Reichsluftfahrtministeriums von Sagebiel zu einem modernen Großflughafen für bis zu sechs Millionen Passagiere pro Jahr umgebaut wurde. Hinter einer streng gerasterten Stadtfassade, die großflächig mit Natursteinplatten aus Muschelkalk verkleidet wurde, entfaltet sich im Innern – etwa in der Abfertigungshalle – ein aus heutiger Sicht durchaus revolutionärer Umgang mit funktionaler Komplexität inklusive Ebenentrennungen. Daran schließt sich Richtung Flugfeld eine im offenen Rund auskragende Flughalle an, die von einer über vierzig Meter hoch reichenden stählernen Konstruktion überdacht wird. Darunter finden bis zu zwölf Meter hohe Flugzeuge Platz – jedenfalls bis 2008, als der Flughafen wohl

Stephan Trüby

tournaments, electric racing car world championships, trade fairs such as the fashion event Bread & Butter. Even a tent city for three-thousand refugees was located in the hangars from late October 2015 to December 2018. Currently, the Allied Museum is planning to move into Hangar 7, and the Berlin Senate's "Urban Development Concept 2030" intends for the airport to become a place of experimentation and a new urban quarter for art, culture, and the creative industries.[15]

The fact that the majority of airport and industrial architecture is continuously used without any outrage is particularly surprising when considering that the German industry was heavily involved in war preparations and later in the war economy, including the systematic use of forced labor. The Volkswagen factory can serve as an apt example: built between 1937 and 1938 by Karl Kohlbecker, Martin Kremmer, Emil Rudolf Mewes, and Fritz Schupp as the Stadt des KdF-Wagens bei Fallersleben (City of the KdF Car near Fallersleben)—renamed Wolfsburg in 1945—its significant, approximately 1.3-kilometer-long factory front included a combined heat and power plant along the Mittelland Canal. As the war started immediately after completion, the KdF car was not mass produced in the factory, as originally planned. Instead, mainly vehicles for the Wehrmacht and the SS such as the *Kübelwagen* (over 50,000) or the Type 166 *Schwimmwagen* (almost 15,000), as well as T-mines, anti-tank rocket launchers, and repair parts for the Junkers Ju-88, were manufactured. The construction of the V1 "revenge weapon" also took place in a secret department at the Volkswagen factory. Around twenty-thousand people had to perform forced labor at Volkswagen between 1940 and 1945. In 1941 and 1942 the chief executive of Volkswagenwerk GmbH, Ferdinand Porsche, was the first economic leader to personally request Reichsführer-SS Heinrich Himmler and Hitler to provide Soviet prisoners of war or concentration camp inmates, in order to more speedily implement construction measures and meet production targets on the factory premises. He also had them quartered in a "model project" concentration camp, euphemistically referred to as *Arbeitsdorf* (work village), on the factory premises in 1942, where they performed forced labor and had to live in damp, windowless air-raid shelters in a foundry building under construction. More than 140 prisoners perished in the Laagberg camp—a subcamp of the Neuengamme concentration camp—also commissioned by Volkswagen in 1944.[16] A memorial in a former air-raid shelter on the factory grounds has commemorated the Volkswagen forced laborers in general, and the "work village" concentration camp in particular, since 1999. However, the premises of the Laagberg subcamp were built over in the postwar period; during excavation works for a planned shopping center, the remains of the foundations of a concentration camp barracks were found and secured as exhibits for a planned learning and memorial site. At the site itself, red pavement is today the only reminder of parts of the foundation [Fig. 7].

4. Air-Raid Shelter Buildings Conformable to Anticipated Brutalism

While the intellectual and also gradual military mobilization for the offensive war unfolded via "blood-and-soil" Heimatschutz architecture in the housing sector, via Pathe-

für immer schloss. Seither jagt eine Zwischennutzung die nächste: Eishockey-Events, Reitturniere, Elektrorennwagen-Weltmeisterschaften, Messen wie die Modemesse Bread & Butter. Sogar eine Zeltstadt für 3.000 Flüchtlinge befand sich von Ende Oktober 2015 bis Dezember 2018 in den Hangars. Aktuell plant das AlliiertenMuseum einen Umzug in den Hangar 7, und im „Entwicklungskonzept 2030+" des Senats heißt es: „Der Flughafen soll in den kommenden Jahren zu einem Experimentierort und neuem Stadtquartier für Kunst, Kultur und Kreativwirtschaft werden."[15]

Dass das Gros der Flughafen- und Industriearchitektur empörungslos weiter nutzbar ist, verwundert insbesondere vor dem Hintergrund, dass die deutsche Industrie in die Kriegsvorbereitungs- und später in die Kriegswirtschaft samt systematischem Einsatz von Zwangsarbeiter*innen im großen Stil eingebunden war. Exemplarisch hierfür ist das 1937 bis 1938 von Karl Kohlbecker, Martin Kremmer, Emil Rudolf Mewes und Fritz Schupp errichtete Volkswagenwerk in der Stadt des Kdf-Wagens bei Fallersleben – ab 1945 Wolfsburg – mit seiner signifikanten, rund 1,3 Kilometer langen Werksfront inklusive Heizkraftwerk entlang des Mittellandkanals. Aufgrund des Kriegsbeginns unmittelbar nach Fertigstellung dieser Fabrik wurde dort nicht – wie ursprünglich geplant – der KdF-Wagen massenhaft produziert, sondern vor allem Fahrzeuge für die Wehrmacht und die SS wie der Kübelwagen – über 50.000 Stück – oder der Schwimmwagen vom Typ 166 – fast 15.000 Stück –, aber auch Tellerminen, Panzerfäuste sowie Reparaturteile für die Junkers Ju-88. Außerdem erfolgte dort in einer geheimen Abteilung auch der Bau der „Vergeltungswaffe V1". Ungefähr 20.000 Menschen mussten bei Volkswagen zwischen 1940 und 1945 Zwangsarbeit verrichten. Um Baumaßnahmen und Fertigungsziele auf dem Werksgelände schneller umsetzen zu können, forderte in den Jahren 1941 und 1942 der Hauptgeschäftsführer der Volkswagenwerk GmbH, Ferdinand Porsche, als erster Wirtschaftsführer beim „Reichsführer SS" Heinrich Himmler und bei Hitler persönlich nicht nur sowjetische Kriegsgefangene respektive KZ-Häftlinge an – er ließ sie auch in einem „Modellprojekt" auf dem euphemistisch „Arbeitsdorf" genannten Konzentrationslager auf dem Werksgelände einquartieren, wo sie 1942 Zwangsarbeit verrichteten und in feuchten, fensterlosen Luftschutzkellern eines im Bau befindlichen Gießereigebäudes hausen mussten. Im ebenfalls von Volkswagen 1944 beauftragten Lager Laagberg – einem Außenlager des KZ Neuengamme – kamen mehr als 140 Häftlinge um.[16] An die VW-Zwangsarbeiter*innen im Allgemeinen und das KZ Arbeitsdorf im Besonderen erinnert seit 1999 eine Erinnerungsstätte in einem ehemaligen Luftschutzbunker auf dem Werksgelände. Die Flächen des KZ-Außenlager Laagberg wurden in der Nachkriegszeit jedoch überbaut; bei Grabungsarbeiten für ein geplantes Einkaufszentrum stieß man jedoch auf Fundamentreste einer KZ-Baracke, die ausgegraben wurden, um sie zu Exponaten eines geplanten Lern- und Gedenkorts zu machen. An Ort und Stelle des Außenlagers erinnern lediglich rote Pflasterungen an den Verlauf einiger Fundamente [Abb. 7].

tischer Funktionalismus including "Luftwaffe Modernism" in the realms of state control and administration, and in the industry sector via modern Functionalist architecture, the construction of a home front built upon bunkers took place—albeit somewhat delayed—in a kind of anticipated Brutalism. This was primarily achieved with the so-called *Führer-Sofort-programm* (Führer emergency program), also known as the *Luftschutz-Sofortprogramm* (air-protection emergency program) based on a *Führerbefehl* (Führer directive) from October 10, 1940, which initiated the construction of air-raid shelters for all cities in the German Reich deemed at risk of attack by enemy aircraft and with populations above the one-hundred-thousand threshold. About two-thousand bunkers in seventy-six cities were fully built or completed to some extent by mid-1943. As part of the program, Munich's Blumenstraße high-rise bunker, based on plans by Karl Meitinger, was constructed by the city's building department in 1941 as one of the city's forty-eight bunkers with similar capacities, each intended to provide shelter from air raids for up to 1,200 people. Since the inner-city bunkers in particular were required to fit into the urban context, the Blumenstraße bunker was based on baroque defense towers. Built on a square ground plan, it is crowned by a wooden pavilion roof that, in the event of a bombing, would protect the two-meter thick, flat concrete ceiling below [Fig. 8]. Since the end of the Second World War, Munich has been debating what should ideally become of the structure: A space for dining? Or rather a museum on the subject of the air war and the defense bunkers, focused around the collection of specialist Karlheinz Kümmel's documents? Things turned out differently. In 2021, the decision was made to open the bunker as a public center for architecture. The director of the Architekturgalerie München, Nicola Borgmann, has been organizing exhibitions at the Blumenstraße bunker. With each new iteration, the bunker is transformed and opened up spatially one step further: "Everyone who exhibits in the bunker also contributes a step to the transformation."[17]

7

The fact that the Führer-Sofortprogramm could only be rapidly implemented by using forced laborers is not given appropriate attention in the ongoing discussions around converting bunkers. In the reception of bunker conversions, analysis of the production conditions of Nazi bunkers is strangely absent—especially when they are converted into combined living and museum spaces, as was prominently the case twice in Germany in recent years. One of these instances is the

4. Luftschutzbunker-Bauten gemäß eines vorweggenommenem Brutalismus

Während die geistige und nach und nach auch militärische Mobilmachung für den Angriffskrieg im Bereich Wohnen via „Blut-und-Boden"-Heimatschutzarchitektur, im Bereich der staatlichen Steuerung und Verwaltung via pathetischem Funktionalismus inklusive „Luftwaffen-Moderne" und im Bereich Industrie sich via modern-funktionalistischer Architektur teilweise hinter monumentalisierenden Fassaden vollzog, erfolgte – zeitlich etwas versetzt – der Aufbau einer bunkergestützten *Home Front* in einer Art vorweggenommenem Brutalismus. Und zwar vor allem mit dem „Führer-Sofortprogramm", auch „Luftschutz-Sofortprogramm" genannt, auf Grundlage eines „Führerbefehls" vom 10. Oktober 1940, mit dem der Bau von Luftschutzbunkern in allen „luftgefährdeten" Städten mit mehr als 100.000 Einwohnern im Deutschen Reich initiiert wurde. Im Rahmen dieses Bauprogramms wurden bis Mitte 1943 ca. 2.000 Bunker in 76 Städten ganz oder einigermaßen fertiggestellt. Auch der Münchner Hochbunker Blumenstraße wurde im Rahmen dieses Programms im Jahre 1941 nach Plänen von Karl Meitinger durch das städtische Baureferat errichtet – als einer von 48 Bunkern mit ähnlicher Kapazität in der Stadt, in denen jeweils bis zu 1.200 Menschen Schutz vor Luftangriffen finden sollten. Da insbesondere die innerstädtischen Bunker sich in den städtischen Kontext einfügen sollten, orientiert sich der Blumenstraße-Bunker an barocken Wehrtürmen: Auf quadratischem Grundriss errichtet, wird er von einem hölzernen Zeltdach bekrönt, das im Falle eines Bombenabwurfs die flach darunter liegende und zwei Meter dicke Betondecke schützen würde, so die Hoffnung des Architekten [Abb. 8]. Seit dem Ende des Zweiten Weltkriegs wurde in München diskutiert, was aus dem Bauwerk idealerweise werden sollte: Gastronomie? Ein Museum zum Thema Luftkrieg und Bunker, aufbauend auf der Dokumentensammlung des Spezialisten Karlheinz Kümmel? Es kam anders, denn 2021 fiel der Beschluss, den Bunker zu einem öffentlichen Zentrum für Architektur zu öffnen. Seither realisiert die Leiterin der Architekturgalerie München Nicola Borgmann hier zahlreiche Ausstellungen – und mit jeder wird der Bunker Stück für Stück umgebaut und räumlich geöffnet: „Jeder, der im Bunker ausstellt, übernimmt auch einen Planungsschritt der Transformation."[17]

8

Stephan Trüby

Friedrichstraße Reich Railway Bunker, built in 1943 by Karl Bonatz in Berlin-Mitte: The building, which was originally intended to provide shelter for 2,500 Reichsbahn travelers, has an eventful history. From 1952, it served as a warehouse for textiles, and from 1957 as a storage space for dried and tropical fruit from Cuba, managed by the Volkseigener Betrieb Kombinat Obst Gemüse Speisekartoffeln (State-Owned Company Fruit Vegetables Potatoes)—hence its temporary nickname "banana bunker." In 1992, the building was converted into a techno club with a fetish and BDSM club in the garden. In 2003, it was acquired by the entrepreneur and collector Christian Boros, who had it converted into a private museum, the Boros Collection, plus a penthouse by the Berlin studio Realarchitektur under the helm of Jens Casper. Since 2007, the collection has been open to the public by appointment. The high-rise bunker in Munich's Ungererstraße, which was also completed in 1943 and during wartime provided space for 702 people on seven floors, likewise "owes" its existence to the Führer-Sofortprogramm. The façade's historicizing decorative elements were intended to ensure compatibility with Munich's transformation into the "capital of the movement" and to avert negative attention in peacetime. Listed as a historic monument in 2010, the building was purchased in the same year by the Munich real estate developer Stefan Höglmaier—Euroboden—and by 2013 had been converted into a combined museum and apartment building based on the Boros model. Starnberg firm Raumstation Architekten provided the design and plans. A four-hundred-square-meter penthouse was created on the top floor—occupied by Höglmaier himself—as well as four loft apartments each 120 square meters, plus offices and an art space to present exhibits from Höglmaier's collection as well as works on loan. In press articles, it is referred to as the "noble bunker"[18] and "tower of prestige,"[19] accompanied by grandiose descriptions: "Bare concrete, cast by Nazis, and fancy interiors by modern architects: A contrast that pervades the rooms in the newly renovated Euroboden high-rise bunker with excitement."[20] Both the Boros and Höglmaier projects are based on structures built by forced laborers. Apparently, in the eyes of many observers, exhibiting art—sometimes accompanied by fancy living quarters—is enough to create a sense of psychological habitability while not entirely forgetting the building's history of violence.

5. Representative Buildings for Cult Purposes Conformable to a (Mostly) Classical Aesthetic

Addressing the "high-ranking architecture" of Nazi state ceremonial, party congress, and governmental buildings in Munich or Nuremberg means entering a zone of "political theology" that is still fraught today. Conversions of these buildings were almost always accompanied by a faux pas. Think, for example, of early National Socialist building projects in Munich, such as the two Ehrentempel (temples of honor) completed between 1933 and 1935 according to plans by Paul Ludwig Troost, each dedicated to eight of the sixteen right-wing terrorists killed in the Munich Putsch of 1923. In fact, only fifteen NSDAP members had died, plus a waiter who was killed by accident. He was buried there for reasons of symmetry. The deceased, referred to as "blood witnesses" in

Viel zu wenig präsent in der Diskussion um die Umnutzung der Bunker ist allerdings die Tatsache, dass das „Führer-Sofortprogramm" nur mit Zwangsarbeiter*innen so schnell umgesetzt werden konnte. Die Analyse der Produktionsbedingungen von NS-Bunkern ist merkwürdig abwesend in der Rezeption von Bunkerumnutzungen – insbesondere dann, wenn diese zu kombinierten Wohn- und Museumsräumlichkeiten umgebaut wurden, wie dies in Deutschland in den letzten Jahren gleich zweimal prominent passiert ist. Einmal ist hier der 1943 von Karl Bonatz in Berlin-Mitte errichtete Reichsbahnbunker Friedrichstraße zu erwähnen: Der Bau, der ursprünglich 2.500 Reisenden der Reichsbahn Schutz bieten sollte, weist eine bewegte Nutzungsgeschichte auf. Ab 1952 diente er als Textillager und ab 1957 als Lagerraum für Trocken- und Südfrüchte aus Kuba durch den „Volkseigenen Betrieb Kombinat Obst Gemüse Speisekartoffeln" – daher rührt auch der zeitweilige Spitzname „Bananenbunker". 1992 wurde der Bau zum Techno-Club umgebaut und im Garten wurde parallel dazu ein Fetisch- und BDSM-Club betrieben. 2003 wurde der Bunker vom Unternehmer und Sammler Christian Boros gekauft, der ihn vom Berliner Büro Realarchitektur um Jens Casper zu einem Privatmuseum, der Boros Collection, plus Penthouse umbauen ließ. Seit 2007 kann die Sammlung nach Anfrage öffentlich besucht werden. Auch der ebenfalls 1943 fertiggestellte Hochbunker in der Münchner Ungererstraße, der in Kriegszeiten 702 Menschen auf sieben Geschossen Platz bot, „verdankt" sich dem „Führer-Sofortprogramm". Die historisierenden Schmuckelemente der Fassade sollten für Kompatibilität mit der Umgestaltung Münchens zur „Hauptstadt der Bewegung" sorgen und auch in Friedenszeiten nicht negativ auffallen. Im Jahr 2010 unter Denkmalschutz gestellt, wurde der Bau im selben Jahr vom Münchener Immobilienentwickler Stefan Höglmaier – Euroboden – erstanden und bis 2013 nach Boros-Vorbild zu einem kombinierten Museum und Appartementgebäude umgebaut. Für den Entwurf und die Pläne sorgte das Büro Raumstation aus Starnberg. Es entstanden im Dachgeschoss ein Penthouse auf 400 Quadratmetern – von Höglmaier selbst bezogen – sowie noch vier Loftwohnungen mit je 120 Quadratmetern, dazu noch Büros und ein Kunstraum, in dem Exponate aus Höglmaiers Sammlung und Leihgaben präsentiert werden. In Presseartikeln wird vom „Edelbunker"[18] und vom „Prestige-Turm"[19] berichtet; vollmundig wird geschildert: „Kahler Beton, von Nazis gegossen, und schickes Interieur vom modernen Architekten. Das ist der Gegensatz, der die Räume im frisch renovierten Euroboden Hochbunker mit Spannung durchzieht."[20] Sowohl das Boros- als auch das Höglmaier-Projekt gehen auf Strukturen zurück, die von Zwangsarbeiter*innen errichtet wurden. Offenbar sind Kunst- und Ausstellungsnutzungen, zuweilen kombiniert mit Wohnungen, in den Augen vieler Beobachter*innen hinreichend geeignet, um die Gewaltgeschichte hinter einem Haus gleichzeitig nicht vergessen zu machen und trotzdem psychologisch bewohnbar zu halten.

5. Staatliche Repräsentationsbauten für Kultzwecke gemäß einer (zumeist) klassizierenden Ästhetik

Mit der „High-Ranking-Architektur" von NS-staatlichen Feierlichkeits-, Parteitags- und Repräsentationsbauten in

Nazi propaganda, were transferred to Königsplatz for the inauguration, reburied in metal sarcophagi, and incorporated into Nazi martyrdom rituals until 1945. As the Ehrentempel was hardly damaged in the Second World War, considerations included converting the classical buildings into a gallery space or a café in the immediate postwar period.[21] Architectural historian Winfried Nerdinger noted that "when Cardinal Faulhaber even suggested that this most eminent Nazi shrine … be converted into a Catholic and a Protestant church, … General Eisenhower personally ordered its demolition [in 1947]."[22] Aside from the destruction of the Reich Chancellery, this was, to his knowledge, "the only concrete act of 'coming to terms with the past by demolishing' Nazi buildings; for the rest, following the Allied Control Council decision to denazify the architecture, and removing the Nazi inscriptions, emblems, and national symbols, was deemed sufficient."[23] Today, only the foundations of the temple buildings remain visible—one overgrown with greenery, the other not [Fig. 9].[24]

The buildings of the Nazi party rally grounds in Nuremberg, which were erected according to plans by Albert Speer between 1935 and the construction stoppage in 1938, can also be described within the framework of a "political theology." The only completed construction on the grounds, the Zeppelin field—built between 1935 and 1937 and featuring a *Zeppelinhaupttribüne* (Zeppelin field grandstand) modeled after the Pergamon Altar—is considered the central Nazi terrain on which the "staging of allegiance and leadership" not only found its form but also its dramaturgy.[25] The Reich party rallies were conceived as highlights in the Nazi calendar of festivities.[26] The liturgies given at the rallies followed meticulously planned strategies, overwhelming the crowds with speeches, architecture, and lighting effects. Besides the *Führerrede* (Führer speech), the central elements of the party rallies included the oath of allegiance to Hitler and the consecration of new flags by touching them with the "blood flag."[27] In this way, the participants were sworn into a heroic soldierly attitude to life and, as Hans-Joachim Kunst once put it, virtually "persuaded to die."[28] With the war still under way, the Allies blew up the main grandstand's swastika on April 22, 1945. An at times bizarre history of conversion followed in the postwar period: car races were held around the Zeppelin field grandstand from 1947 on; gatherings of *Vertriebene* (displaced persons) occurred here; and rock concerts with *Flakscheinwerfer* (searchlights) took place. There was even a 1986 concert by Einstürzende Neubauten in the hall below the Zeppelin grandstand, the so-called *Goldener Saal* (golden hall) with its swastika-riddled ceilings [Fig. 10]. Over time, the Zeppelin field grandstand became liable to collapse, due primarily to the 1967 demolition of the colonnades and later the outer towers, which were removed in 1979. In a particularly curious case of conversion, one of the latter's orignally crowning two fire bowls was temporarily used as a children's paddling pool in a nearby open-air swimming arena from 1986 onwards—a literal picture of *völkisch* hot-headedness cooling off [Fig. 11]. Today it is positioned in front of the grandstand's main entrance. The future of the unfinished Congress Hall, built from 1935 onwards by Ludwig and Franz Ruff and modeled on the Colosseum, is currently under debate in the context of the

München oder Nürnberg sei nun eine bis heute belastete Zone der „politischen Theologie" betreten, wo Umnutzungen fast immer auch mit einem Fauxpas einhergehen. Man denke etwa an frühe nationalsozialistische Bauprojekte in München wie etwa die beiden nach Plänen von Paul Ludwig Troost in den Jahren 1933 bis 1935 fertiggestellten „Ehrentempel" für jeweils acht der insgesamt 16 beim Hitler-Ludendorff-Putsch 1923 getöteten Rechtsterroristen. De facto starben nur 15 NSDAP-Mitglieder plus ein zufällig getöteter Kellner, der nur aus Symmetriegründen mit eingesargt wurde. Die in der NS-Propaganda „Blutzeugen" genannten Toten wurden zur Einweihung an den Königsplatz überführt und in Metall-Sarkophagen neu beigesetzt, wo sie bis 1945 in nationalsozialistische Märtyrerkult-Handlungen einbezogen wurden. Im Zweiten Weltkrieg kaum beschädigt, gab es in der unmittelbaren Nachkriegszeit Überlegungen, die klassizierenden Bauten zu einem Galerieraum bzw. zu einem Café umzubauen.[21] Architekturhistoriker Winfried Nerdinger berichtet zudem, dass, „als Kardinal Faulhaber auch noch vorschlug, dieses höchste NS-Heiligtum [...] in eine katholische und eine evangelische Kirche umzuwandeln, [...] General Eisenhower 1947 persönlich die Sprengung" anordnete.[22] Neben der Schleifung der Reichskanzlei sei dies seines Wissens nach „der einzige konkrete Akt einer ‚Vergangenheitsbewältigung durch Abbruch' von NS-Bauten, ansonsten begnügte man sich mit der Durchführung eines alliierten Kontrollratsbeschlusses zur Entnazifizierung der Architektur und entfernte die NS-Inschriften, Embleme und Hoheitszeichen".[23] Heute sind nur die Sockel der Tempelbauten zu sehen, der eine überwuchert von Grün, der andere nicht [Abb. 9].[24]

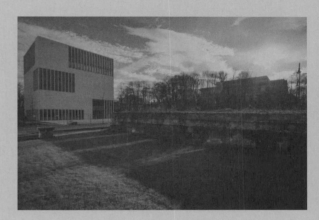

9

Auch die Bauten für das Nürnberger Reichsparteitagsgelände, die zwischen 1935 und dem Baustopp 1938 nach Plänen von Albert Speer errichtet wurden, sind durchaus im Rahmen einer „politischen Theologie" zu beschreiben. Denn, der einzig vollendete Bau des Geländes, nämlich das zwischen 1935 und 1937 fertig gestellte Zeppelinfeld mit seiner am Pergamonaltar orientierten Zeppelinhaupttribüne, gilt als das zentrale NS-Terrain, auf dem die „Inszenierung von Gefolgschaft und Führertum" nicht nur zur Gestalt, sondern auch zur Dramaturgie fand.[25] Die Reichsparteitage waren als Höhepunkte im NS-Feierjahr konzipiert.[26] Die Liturgieformen gehorchten penibel geplanten Überwältigungsstrategien, die mithilfe von Reden, Würdeformeln, Architektur und Lichteffekten auf die

Stephan Trüby

reconversion of the former Nazi party rally grounds. With its un-roofed inner courtyard, it also looks back on an eventful history of conversion, primarily as a storage area for the wooden booths of the Nuremberg Christkindlesmarkt, but also as a parking area for impounded cars; among other things, the parking lot of the neo-Nazi Wehrsportgruppe Hoffmann was temporarily located there. At the moment, it appears that the Nuremberg Opera House, which is in need of renovation, will have its temporary headquarters built in or next to the Congress Hall. In general, one can conclude that sites of National Socialist rituals are difficult or impossible to convert and were also demolished or at least partially destroyed at an early stage due to their high symbolic significance.

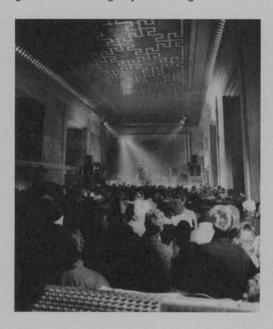

10

6. Concentration and Forced Labor Camps Conformable to Modern-Functionalist Barracks Architecture

The disinhibitions practiced within the framework of National Socialism's "political theology" by means of the *Volks-körper* (people's body) rituals in Nuremberg and elsewhere find their horrifying flip side in the regime's camp architecture. They are certainly indebted to the influence of modern-functionalist thinking, as the example of Fritz Ertl shows, the Austrian architect and Bauhaus student of Wassily Kandinsky who was deputy head of the SS Central Construction Management in the Auschwitz concentration camp. In this position, he also planned the barracks for the Auschwitz-Birkenau concentration camp, which was originally intended as a camp for prisoners of war. A remarkable debate on the ethics of architectural usage and conversion occurred a few years ago regarding former forced labor camps, namely in Berlin, where in 2017 the Barracks 92B, which had been part of the Nazi forced labor camp Berlin-Kaulsdorf, was converted into two luxurious residential units by architectural firm Seemann Torras. An ill-considered phrase that could temporarily be found on the firm's website ignited particular public debate and was then taken up in a tweet by the Department for Research and Information on Antisemitism Berlin, where it was described

Menschenmassen einwirken sollten. Zu den zentralen Elementen der Reichsparteitage gehörte neben einer „Führerrede" auch der Treueschwur der Parteiarmee auf Hitler sowie der mit der „Blutfahne" vollzogene Weiheakt neuer Fahnen und Standarten.[27] So wurden die Teilnehmenden auf eine heroisch-soldatische Lebenseinstellung eingeschworen und gleichsam, wie es Hans-Joachim Kunst einmal formulierte, „zum Tode überredet".[28] Noch während des Kriegs, am 22. April 1945, sprengten die Alliierten das Hakenkreuz der Haupttribüne, und in der Nachkriegszeit folgte eine teils bizarre Umnutzungsgeschichte: Um die Zeppelintribüne herum fanden ab 1947 Autorennen statt, ebenso fahnenbewehrte Vertriebenenversammlungen oder auch Rockkonzerte mit Flakscheinwerfern. Im Saal unter der Zeppelintribüne, dem sogenannten „Goldenen Saal" mit seinem Hakenkreuz-starrenden „Deckenschmuck", kam es 1986 sogar zu einem Konzert der Einstürzenden Neubauten [Abb. 10]. Einsturzgefährdet war die Zeppelintribüne mit der Zeit tatsächlich geworden, bedingt vor allem durch die 1967 erfolgte Sprengung der Kolonnaden und der 1979 entfernten äußeren Türme. In einem besonders kuriosen Umnutzungsfall waren Letztere ursprünglich von zwei Feuerschalen bekrönt, von denen eine ab 1988 zeitweilig als Kinderplanschbecken in einem nahegelegenen Freibad genutzt wurde – als Bild gewordene Abkühlung von völkischer Erhitzung [Abb. 11]. Nun steht sie vor dem Haupteingang der Tribüne. Im Kontext des ehemaligen Reichsparteitagsgelände wird aktuell insbesondere über die Zukunft der unvollendeten, ab 1935 von Ludwig und Franz Ruff nach dem Vorbild des Kolosseums errichteten Kongresshalle debattiert. Auch sie weist mit ihrem nicht überdachten Innenhof eine bewegte Umnutzungsgeschichte auf, vor allem als Lagerfläche für die Bretterbuden des Nürnberger Christkindlesmarktes, aber auch als Parkfläche für beschlagnahmte Autos; unter anderem befand sich dort zeitweilig der Wagenpark der neonazistischen Wehrsportgruppe Hoffmann. Aktuell zeichnet sich dort die Tendenz ab, in oder neben der Kongresshalle das Ausweichquartier für das sanierungsbedürftige Opernhaus Nürnberg zu errichten. Grundsätzlich gilt festzuhalten, dass die Stätten nationalsozialistischer Kulthandlungen schwer bis unmöglich umnutzbar sind und aufgrund ihrer hohen symbolischen Bedeutung auch frühzeitig gesprengt oder zumindest teilweise zerstört wurden.

11

as "irritating": "The concept maintains the character of a barracks without foregoing comfort and aesthetics for a family."[29] A nationwide protest ensued, with social media in particular boiling over. Today, the website of the now defunct office features an explanatory text offering information about the project and stating: "In close cooperation with the Lower Monument Protection Authority and the State Monuments Office, ... a concept was developed that preserves the still existing historical building fabric and its story, while also regarding it as an opportunity to finally let something positive enter the scene."[30] While the conversion of Nazi forced laborer barracks into luxury apartments can encounter fierce responses, other conversions of former forced labor camps have been reacted to in a more relaxed manner. This can be seen, for example, in the Forced Labor Camp Neuaubing," which was built in 1942 to house forced laborers from a Reichsbahn repair shop. After the end of the Second World War, it was first used as refugee accommodation, then as housing for railroad employees and apprentices, and later as workshops for small businesses. In the early 1980s, artists moved into the buildings to use them as studios. A daycare center was also opened. In 2012, the Munich City Council decided to redesign the site to reflect its history. Spatial edges overgrown by greenery are to be restored and façades returned to their former state. One particularly well-preserved barracks will house a branch of the Munich Documentation Centre for the History of National Socialism, scheduled to open in 2024.

In contrast to the former forced labor camps, which, with a few exceptions, have been demolished and often forgotten, the concentration and extermination camps have all been converted into documentation centers or places of learning and remembrance—a profane conversion or new building project would be self-evidently out of the question for reasons of piety. However, this is a more recent development, as the example of the Flossenbürg concentration camp demonstrates. Like many other concentration camps, Flossenbürg was used after the Second World War as an Allied camp for prisoners of war and later for displaced persons. However, unlike other concentration camps, a housing estate was built in Flossenbürg in 1958 on parts of the site, with its hillside location to this day allowing "panoramic views" of the camp-grounds [Fig. 12]. This came about because after the Second World War the American authorities handed over the former concentration camp site to the Bavarian Finance Administration as a trust company. The Bavarian Finance Administration then leased everything to a quarry company that organized for approximately thirty residential buildings to be constructed on the "camp terraces," intended for its recruited workers from the Sudetenland and Silesia. On August 8, 1961, the *Oberpfälzer Nachrichten* newspaper ran with the headline: "Former concentration camp site beautifully developed." First, furniture was produced around the former parade ground, then tennis rackets, and later, in a new factory that completely filled the space, cable harnesses for cars. The approximately three-hundred employees of Ke-Autoelektric, a temporary supplier to Bosch, used the former prisoners' bathroom as a canteen. It was not until the French company Alcatel took over the cable factory that a manager, while there

6. Konzentrations- und Zwangsarbeiterlager gemäß einer modern-funktionalistischen Baracken-Architektur

Die im Rahmen der „politischen Theologie" des National-sozialismus eingeübten Enthemmungen mittels „Volkskör-per"-Inszenierungen in Nürnberg und anderswo finden ihre schreckliche Kehrseite in den Lagerarchitekturen des Regi-mes. Sie verdanken sich durchaus dem Einfluss modern-funk-tionalistischen Denkens, wie das Beispiel von Fritz Ertl zeigt, dem österreichischen Architekten und Bauhaus-Schüler von Wassily Kandinsky, der im KZ Auschwitz stellvertretender Leiter der SS-Zentralbauleitung war und in dieser Funktion auch die Baracken für das ursprünglich als Kriegsgefange-nenlager geplante KZ Auschwitz-Birkenau plante. Vor allem im Bereich ehemaliger Zwangsarbeiterlager kam es vor weni-gen Jahren zu einer bemerkenswerten Umnutzungsdebatte – und zwar in Berlin, wo im Jahre 2017 die sogenannte „Baracke 92B", die Teil des NS-Zwangsarbeiterlagers Berlin-Kaulsdorf war, vom Architekturbüro Seemann Torras zu zwei luxuriösen Wohneinheiten umgebaut wurde. Eine öffentliche Debatte entzündete sich insbesondere an einem unbedachten Satz, der sich zeitweilig auf der Website des Architekturbüros fand, daraufhin von der Recherche- und Informationsstelle Antisemitismus Berlin in einem Tweet aufgegriffen und als „irritierend" bezeichnet wurde: „Das Konzept erhält den Cha-rakter einer Baracke ohne auf Komfort und Ästhetik für eine Familie zu verzichten."[29] Es folgte ein landesweiter Shitstorm gegen das Büro, der insbesondere in den sozialen Medien heiß lief. Auf der Website des mittlerweile aufgelösten Büros findet sich heute ein Erläuterungstext mit Informationen zu dem Projekt, in dem geschrieben steht: „In enger Zusammen-arbeit mit der Unteren Denkmalschutzbehörde und dem Lan-desdenkmalamt wurde [...] ein Konzept entwickelt, dass die noch vorhandene historische Bausubstanz und seine Ge-schichte bewahrt, es aber auch als Chance sieht, endlich et-was Positives einkehren zu lassen."[30] Während die Umnut-zung von NS-Zwangsarbeiterbaracken in Luxuswohnungen auf heftige Resonanz stoßen kann, wird bei anderen Umnut-zungen von ehemaligen Zwangsarbeiterlagern entspannter reagiert. Dies zeigt etwa das Münchner Beispiel „Zwangsar-beiterlager Neuaubing", das 1942 zur Unterbringung von Zwangsarbeitern eines Reichsbahn-Ausbesserungswerks errichtet wurde. Nach dem Ende des Zweiten Weltkriegs zu-nächst als Flüchtlingsunterkunft, dann als Wohnanlage für Bahnangestellte bzw. Lehrlinge und später als Werkstätten für Kleingewerbe genutzt, zogen Anfang der 1980er Jahre Künstler*innen in die Gebäude ein, um sie als Ateliers zu nut-zen. Auch eine Kita wurde eröffnet. 2012 beschloss der Münchner Stadtrat, das Gelände so umzugestalten, dass die Geschichte des Ortes deutlich wird. So sollen von Grün über-wucherte Raumkanten wiederhergestellt und Fassaden in den alten Zustand zurückversetzt werden. Eine besonders gut erhaltene Baracke wird zu einer Zweigstelle des NS-Doku-mentationszentrums, die 2024 eröffnen soll.

Im Gegensatz zu den bis auf wenige Ausnahmen abgeris-senen und oftmals vergessenen ehemaligen Zwangsarbeiter-lagern wurden die Konzentrations- und Vernichtungslager allesamt zu Dokumentationszentren bzw. Lern- und Gedenk-orten umfunktioniert – aus Pietätsgründen verbietet sich hier eine profane Umnutzung oder Überbauung von selbst. Wo-

Stephan Trüby

on a business trip in 1997 to oversee his company's recent asset acquisition, instigated a change in consciousness: the manager's father had been a prisoner in the Buchenwald concentration camp, and from then on he was committed to relocating the company.

Reevaluation of All Values: The Decorum of Converted NS Architecture in Active Use

The panorama illustrated here of legacy Nazi architecture conversions—though only fragmentary—represents a challenge for the still evolving architectural theory of conversion. So far, it has only been rudimentarily explored with a few publications by Bernard Tschumi, among others. The French-Swiss architect dealt with the built legacy of National Socialism early on—including in his 1981 essay "Violence of Architecture," in which he developed the dystopia of a *ballet mécanique* of architecture and presented it as "a permanent Nuremberg Rally of everyday life" where every movement is programmed.[31] In his 1987 essay "Abstract Mediation and Strategy," Tschumi differentiated between three forms of architectural programming processes: firstly, "transprogramming," by which Tschumi means the combination of two programs, however incongruous they may be, for example a planetarium and a roller coaster;[32] secondly, "disprogramming," by which he means the combination of two programs, whereby the spatial configuration of one program contaminates the other;[33] and thirdly, "crossprogramming," which refers to repurposing in the narrower sense, for example, the transformation of a prison into a town hall.[34] Only the latter type concerns buildings from the National Socialist era and what to do with them. Casting a "crossprogramming" perspective on Nazi architecture reveals a hidden structure of decorum in Nazi architectural use. Classical decorum is a multi-medial ranking system that emerged from ancient rhetoric and emphasized appropriateness and accuracy: "Language and subject matter should be adapted: a sublime subject demands a sublime style, a plain subject a plain style."[35] This decorum addressed all of society and its artifacts. The position of a building within the spectrum of decorum could be ascertained from its *ornamentum*. The ornamentum was related to the decorum as the single note is to the keyboard. The highest ornamentum was reserved only for buildings that showed a great proximity to war: mainly temples and triumphal arches.[36] Spanning the two poles of

12

bei diese Entwicklung durchaus eine jüngere ist, wie das Beispiel des KZ Flossenbürg zeigt. Wie viele andere Konzentrationslager auch, wurde Flossenbürg nach dem Zweiten Weltkrieg als alliiertes Lager für Kriegsgefangene und später für *Displaced Persons* genutzt. Doch anders als bei anderen Konzentrationslagern wurde in Flossenbürg im Jahre 1958 auf Teilen des Geländes eine Wohnsiedlung errichtet, deren Hanglage bis heute „Panoramablicke" auf das Lagergelände erlaubt [Abb. 12]. Hierzu kam es dadurch, dass die US-amerikanische Besatzungsmacht nach dem Zweiten Weltkrieg das ehemalige KZ-Gelände an die Bayerische Finanzverwaltung als Treuhandbetrieb übergab, die wiederum alles an einen Steinbruchbetrieb verpachtete, der für seine angeworbenen Arbeitskräfte aus dem Sudetenland und Schlesien auf den „Lagerterrassen" über ein gemeinnütziges Siedlungswerk Hausbauflächen für rund dreißig Eigenheime vermittelte. Die *Oberpfälzer Nachrichten* titelten am 8. August 1961: „Ehemaliges KZ-Gelände schön bebaut". Um den ehemaligen Appellplatz herum wurden in der Nachkriegszeit zunächst Möbel, dann Tennisschläger und später, in einer neuen, den Appellplatz völlig ausfüllenden Fabrik, Kabelbäume für Autos produziert. Die ca. 300 Angestellten der Firma Ke-Autoelectric, einem zeitweiligen Zulieferer von Bosch, nutzten das frühere Häftlingsbad für Frühstück und Pausen, und erst als das französische Unternehmen Alcatel die Kabelfabrik übernahm und ein Manager 1997 auf Dienstreise vor Ort realisierte, wo sein Unternehmen sich eingenistet hat, setzte ein Bewusstseinswandel ein: Der Vater des Managers war Häftling im KZ Buchenwald, und fortan engagierte er sich für eine Standortverlegung.

Umwertung aller Werte: das Decorum der weiter- und umgenutzten NS-Architektur

Das hier entfaltete – und gleichwohl nur fragmentarisch sichtbar gewordene – Umnutzungspanorama von gebauten NS-Hinterlassenschaften stellt eine Herausforderung für die sich noch im Aufbau befindende Architekturtheorie der Umnutzung dar. Diese liegt nur rudimentär mit ein paar überschaubaren Texten etwa von Bernard Tschumi vor. Der französisch-schweizerische Architekt hat sich schon frühzeitig mit dem gebauten Erbe des Nationalsozialismus auseinandergesetzt – etwa 1981 in seinem Aufsatz „Die Gewalt der Architektur", in dem er die Dystopie eines *ballet mécanique* der Architektur entfaltet – und diesen als einen „Nürnberger Reichsparteitag des Alltagslebens" vorstellt, in dem jede Bewegung vorgeschrieben ist.[31] In seinem Aufsatz „Abstract Mediation and Strategy" von 1987 differenziert Tschumi drei Formen von architektonischen Programmierungsvorgängen: erstens „transprogramming" – damit meint Tschumi die Kombination zweier Programme, und seien sie noch so unpassend, zum Beispiel Planetarium und Achterbahn;[32] zweitens „disprogramming" – damit meint er die Kombination zweier Programme, wobei die Raumkonfiguration des einen Programms das andere kontaminiert;[33] und drittens „crossprogramming" – die Umnutzung im engeren Sinne, also die Transformation beispielsweise eines Gefängnisses in ein Rathaus.[34] Nur letztere Spielart betrifft den Umgang mit Bauten aus der Zeit des Nationalsozialismus. Eine „crossprogramming"-Perspektive auf die NS-Architektur zu werfen,

61

"sublime" and "low," the decorum formed a codification system consistently related to war: "The rank derives its quality from the determination of everything by the war, that is, by the sublime. It expresses: nearest to war, second to war, et cetera."[37]

In contrast to the classical decorum, however, the decorum for reusing and repurposing Nazi architecture necessitates a "reevaluation of all values" in that it is not centered on heroism and war but rather its victims. From what has been noted above, it then should become clear that conversions and reuses of Nazi architecture seem to be reasonably unproblematic as long as they are residential and administrative buildings. A comparative study with construction tasks such as highway service stations or city halls would lead to similar results. Sensitivities are only aggravated by the conversions and reuses of residences of internationally-known Nazi war criminals, such as Obersalzberg, Bogensee in Brandenburg, or locations Hitler was active in like the Reich Chancellery. The conversion and further use of Nazi factories, airports, and Nazi civil defense bunkers seems to be just as unproblematic, even though in almost all cases forced laborers were employed in factories and in the construction of bunkers on a large scale—often with fatal results. In the aforementioned conversions of bunkers built by forced laborers, it is striking that in two known cases the combination of luxury housing and art exhibitions were realized—to wide acclaim—while the conversion of a forced laborers' barracks into luxury apartments led to major waves of indignation, at least in the Berlin example described above. In terms of conversion ethics, therefore, a significant difference between the places where forced laborers worked and the places where they were housed is to be noted. While the conversion and further use of residential buildings, factories, airports, and bunkers appear to be considered acceptable on the whole, conversion plans for sites of Nazi state liturgy, especially in Nuremberg, are continuously met with vehement opposition. They almost always failed if they implied more than just temporary uses. The conversion of former concentration camps, finally, appears completely out of the question. They justifiably became the "holy sites" of a purified Germany, forever confined to functions such as documentation centers or memorials reflecting their former use.

Prof. Dr. phil. Stephan Trüby is Professor of Architecture and Cultural Theory and Director of the Institute for Principles of Modern Architecture (IGmA) at the University of Stuttgart. Previously, he taught at the State College of Design in Karlsruhe, the Zurich University of the Arts, Harvard University, and the Technical University of Munich. His most important books include *Exit-Architecture: Design between War and Peace* (2008), *Die Geschichte des Korridors* (2018), and *Rechte Räume: Politische Essays und Gespräche* (2020).

förderte eine versteckte Decorum-Ordnung der NS-Architektur-Nutzung zutage. Beim klassischen Decorum handelte es sich um ein multimediales Ranking-System, das aus der antiken Rhetorik hervorgegangen war und Angemessenheit und Passgenauigkeit lehrte: „Sprache und Gegenstand sollten aufeinander abgestimmt sein: Ein erhabenes Thema verlangt einen erhabenen, ein schlichtes Thema einen schlichten Stil."[35] Das Decorum legte sich über die gesamte Gesellschaft und ihre Artefakte. Die Position eines Gebäudes innerhalb des Decorum-Spektrums ließ sich am *ornamentum* ablesen. Das *ornamentum* stand zum Decorum wie der einzelne Ton zur Klaviatur. Das höchste *ornamentum* war nur Gebäuden vorbehalten, die eine große Kriegsnähe aufwiesen: vor allem die Tempel und Triumphbögen.[36] Indem sich das Decorum zwischen den beiden Polen „erhaben" und „niedrig" aufspannt, bildet es ein durchweg kriegsbezogenes Kodifizierungssystem: „Der Rang bezieht seine Eigenschaft von der Bestimmung des Ganzen durch den Krieg, das heißt, durch das Erhabene. Er drückt aus: dem Krieg am nächsten, dem Krieg am zweitnächsten usw."[37]

Im Unterschied zum klassischen Decorum ist jedoch für die Decorum-Ordnung der weiter- und umgenutzten NS-Architektur eine „Umwertung aller Werte" insofern festzuhalten, als sie nicht Heroismus- und kriegsbezogen, sondern Opfer-bezogen ist. Es sollte vor dem Hintergrund des Ausgeführten deutlich geworden sein, dass Um- und Weiternutzungen von NS-Architekturen einigermaßen konsensfähig scheinen, solange es sich um Wohnhäuser und Verwaltungsgebäude handelt. Eine vergleichende Untersuchung mit Bauaufgaben wie etwa Autobahnraststätten oder Rathäusern würde zu ähnlichen Ergebnissen führen. Sensibilitäten werden bei derlei Um- und Weiternutzungen nur dann berührt, wenn es sich um Wohnorte von international bekannten NS-Kriegsverbrechern wie dem Obersalzberg, Bogensee in Brandenburg oder zentrale Wirkungsorte von Hitler wie der Reichskanzlei handelt. Ebenso konsensfähig scheint die Um- und Weiternutzung von NS-Fabriken und -Flughäfen sowie NS-Zivilschutzbunkern zu sein, obwohl in Fabriken und beim Bau von Bunkern in fast allen Fällen Zwangsarbeiter*innen zum Einsatz kamen, und zwar in großem Stil – und mit oft tödlichem Ausgang. Bei den erwähnten Umnutzungen der auch von Zwangsarbeiter*innen errichteten Bunkern ist auffällig, dass in gleich zwei bekannten Fällen die Kombination von Luxuswohnung und Kunstpräsentation zur Ausführung kam – und auch goutiert wird –, während eine Umnutzung von Zwangsarbeiterbaracken zu Luxuswohnungen zumindest in dem dargelegten Berliner Beispiel zu größeren Empörungswellen führte. Es ist also umnutzungsethisch ein signifikanter Unterschied zwischen den Arbeitsorten und den Unterbringungsorten von Zwangsarbeiter*innen festzuhalten. Während die Um- und Weiternutzungen von Wohnhäusern, Fabriken bzw. Flughäfen und Bunkern im Großen und Ganzen akzeptabel erscheint, bringen Umnutzungspläne für Stätten der NS-Staatsliturgie insbesondere in Nürnberg bis heute vehemente Diskussionen mit sich. Fast immer scheiterten sie, wenn sie mehr als nur temporäre Bespielungen implizierten. Völlig ausgeschlossen erscheinen Umnutzungen von ehemaligen Konzentrationslagern. Zu Recht wurden sie zu „heiligen Stätten" eines geläuterten Deutschlands, für immer auf Funktionen wie Dokumentationszentren oder Gedenkstätten festgelegt, die die einstige Nutzung in Erinnerung halten.

1 Per Leo, "Historikerstreit 2.0 über Shoah / Historiker Per Leo fordert globale Perspektive auf NS-Verbrechen," interview by Kolja Unger, *Deutschlandfunk*, July 11, 2021, https://www.deutschlandfunk.de/historikerstreit-2-0-ueber-shoah-historiker-per-leo-fordert-100.html.
2 Stephan Trüby, *Rechte Räume: Politische Essays und Gespräche* (Basel: De Gruyter, 2020).
3 Adolf Hitler quoted in Helmut Weihsmann, *Bauen unterm Hakenkreuz: Architektur des Untergangs* (Promedia Verlag: Vienna, 1998), 19 [translated by Lisa Contag].
4 Joachim Petsch, "Architektur als Weltanschauung: Die Staats- und Parteiarchitektur im Nationalsozialismus," in *Faszination und Gewalt. Zur politischen Ästhetik des Nationalsozialismus*, eds. Bernd Ogan and Wolfgang W. Weiß (Nuremberg: Tümmel Verlag, 1992), 199.
5 Norbert Borrmann, "'Kulturbolschewismus' oder 'Ewige Ordnung,'" in *Architektur und Ideologie im 20. Jahrhundert* (Graz: Ares Verlag, 2009), 131.
6 The term Pathetischer Funktionalismus was coined by Helmut Weihsmann and describes in its German language connotation the Nazi's kitschy and overblown approach to a fundamentally functional building style that emerged as part of the modern architectural vocabulary.
7 Weihsmann, *Bauen unterm Hakenkreuz*, 19.
8 Stephan Trüby, "Eine 'Neue Rechte' gibt es nicht," *ARCH+ 235: Rechte Räume: Bericht einer Europareise*, May 2019.
9 Cf. Carl Schmitt, *Politische Theologie* (Berlin: Duncker & Humblot, 2009).
10 Jan Sellner, "Verkaufte Schmitthenner-Villa in Stuttgart: Denkmalschützer winken ab," *Stuttgarter Zeitung*, October 22, 2021, https://www.stuttgarter-zeitung.de/inhalt.verkaufte-schmitthenner-villa-in-stuttgart-denkmalschuetzer-winken-ab.6ce43367-114a-4861-8f14-6bfc2bfa9edb.html.
11 Eva Funke, "Wohnen in Stuttgart-Nord: Vor Besuch der Denkmalschützer abgerissen," *Stuttgarter Zeitung*, October 31, 2019, https://www.stuttgarter-zeitung.de/inhalt.wohnen-in-stuttgart-nord-vor-besuch-der-denkmalschuetzer-abgerissen.314673d0-9899-4ac3-a799-f43485055574.html.
12 Walter Krüttner's documentary short film *Es muß ein Stück vom Hitler sein* (1963) addresses this subject.
13 Anonymous, "Geheim-Operation. Reichsbürger wollen wohl Areal mit Goebbels-Villa übernehmen," *Focus*, August 12, 2021, https://www.focus.de/wissen/koenigreich-deutschland-reichsbuerger-wollen-offenbar-areal-um-goebbels-villa-fuer-sich-beanspruchen_id_13631480.html.
14 In her book *Ernst Sagebiel: Leben und Werk 1892–1970* (Berlin: Lukas Verlag, 2005), Elke Dittrich debunked this concept as a "myth" and contradicted any insinuation that the architecture of the Luftwaffe was intended to consciously express its self-image as a technological avant-garde.
15 Dirk Krampitz, "Umzug zum Flughafen Tempelhof: 5000 Quadratmeter im Hangar 7 als neue Heimat für das Alliiertenmuseum," *B.Z.*, October 26, 2021, https://www.bz-berlin.de/berlin/tempelhof-schoeneberg/5000-quadratmeter-im-hangar-7-als-neue-heimat-fuer-das-alliiertenmuseum.
16 Cf. "Fallersleben-Laagberg (Männer)," KZ-Gedenkstätte Neuengamme, accessed December 12, 2021, https://www.kz-gedenkstaette-neuengamme.de/geschichte/kz-aussenlager/aussenlagerliste/fallersleben-laagberg-maenner/.

1 Vgl. Per Leo im Gespräch mit Kolja Unger, *Historikerstreit 2.0 über Shoah | Historiker Per Leo fordert globale Perspektive auf NS-Verbrechen*, in: Deutschlandfunk [11.07.2021], URL: https://www.deutschlandfunk.de/historikerstreit-2-0-ueber-shoah-historiker-per-leo-fordert-100.html (letzter Zugriff: 12.12.2021).
2 Vgl. Stephan Trüby, *Rechte Räume. Politische Essays und Gespräche*, Berlin, Basel 2020.
3 Adolf Hitler, zit. nach Helmut Weihsmann, *Bauen unterm Hakenkreuz. Architektur des Untergangs*, Wien 1998, S. 19.
4 Joachim Petsch, „Architektur als Weltanschauung. Die Staats- und Parteiarchitektur im Nationalsozialismus", in: Bernd Ogan, Wolfgang W. Weiß (Hg.), *Faszination und Gewalt. Zur politischen Ästhetik des Nationalsozialismus*, Nürnberg 1992, S. 199.
5 Norbert Borrmann, *„Kulturbolschewismus" oder „Ewige Ordnung". Architektur und Ideologie im 20. Jahrhundert*, Graz 2009, S. 31.
6 Vgl. Weihsmann, *Bauen unterm Hakenkreuz* (wie Anm. 3).
7 Vgl. Stephan Trüby, „Eine ‚Neue' Rechte gibt es nicht", in: *ARCH+ 235: Rechte Räume. Bericht einer Europareise*, Mai 2019; Wiederabdruck in: Trüby (wie Anm. 2), S. 96ff.
8 Vgl. Carl Schmitt, *Politische Theologie*, Berlin 2009 [1922].
9 Jan Sellner, *Verkaufte Schmitthenner-Villa in Stuttgart. Denkmalschützer winken ab*, in: Stuttgarter Zeitung [22.10.21], URL: https://www.stuttgarter-zeitung.de/inhalt.verkaufte-schmitthenner-villa-in-stuttgart-denkmalschuetzer-winken-ab.6ce43367-114a-4861-8f14-6bfc2bfa9edb.html (letzter Zugriff: 12.12.21).
10 Eva Funke, *Wohnen in Stuttgart-Nord. Vor Besuch der Denkmalschützer abgerissen*, in: Stuttgarter Zeitung [31.10.19], URL: (https://www.stuttgarter-zeitung.de/inhalt.wohnen-in-stuttgart-nord-vor-besuch-der-denkmalschuetzer-abgerissen.314673d0-9899-4ac3-a799-f43485055574.html (letzter Zugriff: 12.12.21).
11 Walter Krüttners dokumentarischer Kurzfilm *Es muß ein Stück vom Hitler sein* (1963) beschäftigt sich mit dieser Thematik.
12 Vgl. Anonymus, *Geheim-Operation. Reichsbürger wollen wohl Areal mit Goebbels-Villa übernehmen*, in: Focus [12.08.2021], URL: https://www.focus.de/wissen/koenigreich-deutschland-reichsbuerger-wollen-offenbar-areal-um-goebbels-villa-fuer-sich-beanspruchen_id_13631480.html (letzter Zugriff: 12.12.21).
13 Dieser Begriff stammt von Helmut Weihsmann.
14 Elke Dittrich hat in ihrem Buch *Ernst Sagebiel. Leben und Werk 1892 – 1970* (Berlin 2005) diesen Begriff als „Mythos" entlarvt und jeglicher Insinuation, die Architektur der Luftwaffe habe deren Selbstverständnis als technische Avantgarde bewusst zum Ausdruck bringen sollen, widersprochen.
15 Dirk Krampitz, *Umzug zum Flughafen Tempelhof: 5000 Quadratmeter im Hangar 7 als neue Heimat für das Alliiertenmuseum*, in: B.Z. [26.10.21], URL: https://www.bz-berlin.de/berlin/tempelhof-schoeneberg/5000-quadratmeter-im-hangar-7-als-neue-heimat-fuer-das-alliiertenmuseum (letzter Zugriff: 12.12.21).
16 Vgl. *Geschichte zu Fallersleben-Laagberg (Männer)*, URL: https://www.kz-gedenkstaette-neuengamme.de/geschichte/kz-aussenlager/aussenlagerliste/fallersleben-laagberg-maenner/ (letzter Zugriff: 12.12.21).
17 Evelyn Vogel, *Umzug: Licht aus! Spot an!*, in: Süddeutsche Zeitung [20.08.21], URL: https://www.sueddeutsche.de/muenchen/architektur-galerie-bunker-nachhaltigkeit-blumenstrasse-umzug-1.5387844 (letzter Zugriff: 12.12.21).

17 Evelyn Vogel, "Umzug: Licht aus! Spot an!," *Süddeutsche Zeitung*, August 20, 2021, https://www.sueddeutsche.de/muenchen/architektur-galerie-bunker-nachhaltigkeit-blumen-straße-umzug-1.5387844 [translated by Lisa Contag].

18 Christian Pfaffinger, "Der Bunker ist bezugsfertig," *Abendzeitung München*, June 26, 2014, https://www.abendzeitung-muenchen.de/muenchen/stadtviertel/der-bunker-ist-bezugsfertig-art-523931 [translated by Lisa Contag].

19 Ibid.

20 Ibid.

21 Christoph Hackelsberger, *Die aufgeschobene Moderne* (Munich: Deutscher Kunstverlag, 1985), 35.

22 Winfried Nerdinger, "Umgang mit der NS-Architektur: Das schlechte Beispiel München," in, *Faszination und Gewalt. Zur politischen Ästhetik des Nationalsozialismus*, eds. Bernd Ogan and Wolfgang W. Weiß (Nuremberg: Tümmel Verlag 1992), 241 [translated by Lisa Contag].

23 Ibid.

24 Martin Bernstein, "Königsplatz: NS-Dokuzentrum legt Sockel von Nazi-Tempel frei," *Süddeutsche Zeitung*, December 19, 2014, https://www.sueddeutsche.de/muenchen/koenigsplatz-ns-dokuzentrum-legt-sockel-von-nazi-tempel-frei-1.2275736.

25 Bernd Ogan, "Faszination und Gewalt—ein Überblick," in *Faszination und Gewalt: Zur politischen Ästhetik des Nationalsozialismus*, eds. Bernd Ogan and Wolfgang W. Weiß (Nuremberg: Tümmel Verlag, 1992), 20.

26 Siegfried Zelnhefer, "Die Reichsparteitage der NSDAP," in *Faszination und Gewalt: Zur politischen Ästhetik des Nationalsozialismus*, eds. Bernd Ogan and Wolfgang W. Weiß (Nuremberg: Tümmel Verlag, 1992), 79.

27 Ibid., 87.

28 Ogan, *Faszination und Gewalt*, 20.

29 Erik Peter, "Ex-Zwangsarbeitslager in Berlin: Luxus-Wohnen in der Baracke," *taz – die tageszeitung*, April 16, 2019, https://taz.de/Ex-Zwangsarbeitslager-in-Berlin/!5588954/, [translated by Lisa Contag].

30 "Baracke 92B, Marzahn-Hellersdorf, Berlin," Seemann Toras Architektur, accessed December 12, 2021, https://www.st-architektur.com/home/realisierungen/baracke-92b-de/ [translated by Lisa Contag].

31 Bernard Tschumi, "Die Gewalt der Architektur" in *architektur_theorie.doc. Texte seit 1960*, eds. Gerd de Bruyn and Stephan Trüby (Basel : Birkhäuser, 2003, 172); translation: Bernard Tschumi, "Violence of Architecture," in *Deconstruction: A Reader*, ed. Martin McQuillan (New York: Routledge, 2000), 232.

32 Bernard Tschumi, "Abstract Mediation and Strategy" in *Architecture and Disjunction* (Cambridge: MIT Press, 1996), 205.

33 Ibid.

34 Ibid.

35 Gérard Raulet, "Ornament," in *Historisches Wörterbuch der Rhetorik*, ed. Gert Ueding (Tübingen: De Gruyter, 2003), 425 [translated by Lisa Contag].

36 For Leon Battista Alberti, the highest sacred building was the ornamentless city wall, followed in second place by the *templum*. Heiner Mühlmann, *Ästhetische Theorie der Renaissance—Leon Battista Alberti* (Bochum: Verlag Marcel Dolega, 2005).

37 Mühlmann, *Ästhetische Theorie der Renaissance*, 134 [translated by Lisa Contag].

18 Christian Pfaffinger, *Der Bunker ist bezugsfertig*, in: Abendzeitung München [26.06.2014], URL: https://www.abendzeitung-muenchen.de/muenchen/stadtviertel/der-bunker-ist-bezugsfertig-art-523931 (letzter Zugriff: 12.12.21).

19 Ders. ebd.

20 Ders. ebd.

21 Vgl. Christoph Hackelsberger, *Die aufgeschobene Moderne*, München 1985, S. 35.

22 Winfried Nerdinger, „Umgang mit der NS-Architektur. Das schlechte Beispiel München", in: Bernd Ogan, Wolfgang W. Weiß (Hg.), *Faszination und Gewalt. Zur politischen Ästhetik des Nationalsozialismus*, Nürnberg 1992, S. 241.

23 Ders. ebd.

24 Martin Bernstein, *Königsplatz: NS-Dokuzentrum legt Sockel von Nazi-Tempel frei*, in: Süddeutsche Zeitung [19.12.2014], URL: https://www.sueddeutsche.de/muenchen/koenigsplatz-ns-dokuzentrum-legt-sockel-von-nazi-tempel-frei-1.2275736 (letzter Zugriff: 12.12.21).

25 Bernd Ogan, „Faszination und Gewalt – ein Überblick", in: ders. Bernd Ogan, Wolfgang W. Weiß (Hg.), *Faszination und Gewalt. Zur politischen Ästhetik des Nationalsozialismus*, Nürnberg 1992, S. 20.

26 Vgl. Siegfried Zelnhefer, „Die Reichsparteitage der NSDAP", in: Bernd Ogan, Wolfgang W. Weiß (Hg.), *Faszination und Gewalt. Zur politischen Ästhetik des Nationalsozialismus*, Nürnberg 1992, S. 79.

27 Ders. ebd. (wie Anm. 26), S. 87.

28 Zit. nach Ogan, (wie Anm. 25), S. 20.

29 Erik Peter, *Ex-Zwangsarbeitslager in Berlin. Luxus-Wohnen in der Baracke*, in: taz – die tageszeitung [16.04.2019], URL: https://taz.de/Ex-Zwangsarbeitslager-in-Berlin/!5588954/ (letzter Zugriff: 12.12.21).

30 Vgl. Baracke 92B, Marzahn-Hellersdorf, Berlin, URL: https://www.st-architektur.com/home/realisierungen/baracke-92b-de/ (letzter Zugriff: 12.12.21).

31 Bernard Tschumi, „Die Gewalt der Architektur" (1981), in: Gerd de Bruyn, Stephan Trüby (Hg.), *architektur_theorie.doc. Texte seit 1960*, Basel 2003, S. 172.

32 Bernard Tschumi, „Abstract Mediation and Strategy" (1987), in: ders., *Architecture and Disjunction*, Cambridge, Mass./London 1996, S. 205.

33 Ders. ebd. (wie Anm. 32).

34 Ders. ebd. (wie Anm. 32).

35 Gérard Raulet, „Ornament", in: Gert Ueding (Hg.), *Historisches Wörterbuch der Rhetorik*, Tübingen 2003, S. 425.

36 Für Alberti war das höchste Sakralgebäude die ornamentlose Stadtmauer, dann folgte an zweiter Stellen das *templum*. Vgl. Heiner Mühlmann, Ästhetische Theorie der Renaissance – Leon Battista Alberti, Bochum 2005 (1981).

37 Ders. ebd. (wie Anm. 36), S. 134.

Stephan Trüby

Conversation with Sauerbruch Hutton

The editors of the publication sat down with architects Matthias Sauerbruch and David Wegener from Sauerbruch Hutton, one of the major architecture firms based in Berlin. In 2016, they were commissioned to redesign the central building block of the former Luftgaukommando III, and later US headquarters, to become the exhibition space of Fluentum.

Fluentum: We've been in conversation with you ever since we started working at Fluentum in this impressive and complex location. Maybe we could start at the beginning: What was your process like when you started thinking about how this historical site could become relevant again for the twenty-first century?

David Wegener: We first visited the building at the invitation of Mr. Hannebauer. Terraplan and Prinz von Preussen Grundbesitz AG, who had acquired the building from the city of Berlin, were already converting the complex into apartments at that time. The "Marble Gallery," Fluentum's current exhibition space, was basically a shell. We have only seen photos of the condition of the building in the 1930s and then in the 1950s when it was being used by the American military. The situation was like a construction site. For example, all the door lintels in the great hall on the upper floor had been removed or covered up, and the ceiling on the first floor had already been partially dismantled because they were about to install an elevator. That's how we saw the house for the first time. And then we started thinking about the requirements of this building, the gallery, and the private rooms, as well as the actually quite absurd situation that this had already been converted once before.

Essentially, the ideas for the conversion by Sauerbruch Hutton came about on the construction site itself. Right from the start, I was impressed by two things: firstly, that these administrative buildings have been, in a way, desecrated by these relatively stuffy apartments that they have now been made into, because within the residential areas you can't really recognize the original complex anymore. The second point was that the building was constructed in 1935 with a concrete roof structure. So, apparently, bomb safety was already being considered four years before the war. That's how I interpreted it. In a way, that's scary too. When we visited the main building that now houses Fluentum for the first time, we saw this concrete ribbed ceiling behind the suspended ceiling that had already been half dismantled. I thought it was impressive how the architecture purports to have a materiality from another century, while there is actually this ultramodern construction behind it.

When we started, we knew that the Monument Authority would first pursue their primary prerequisite of restoring everything exactly as it had originally been. Only if things have already been remodeled after the first version do they agree to preserve this condition or to allow a third version—a new variant, so to speak—to be implemented. Now, there was this ceiling that was original but already half destroyed. Slowly, the idea arose to remove the suspended ceiling completely. The ceiling in the rotunda had already been removed because

Gespräch mit Sauerbruch Hutton

Das redaktionelle Team der Publikation sprach mit den Architekten Matthias Sauerbruch und David Wegener von Sauerbruch Hutton, einem der führenden Architekturbüros in Berlin. Sie wurden 2016 beauftragt, den zentralen Gebäudeteil des ehemaligen Luftgaukommandos III und späteren US-Hauptquartiers zu den Ausstellungsräumen von Fluentum umzugestalten.

Fluentum: Schon seit wir für Fluentum und in diesem beeindruckenden und komplexen Ort arbeiten, sind wir mit Ihnen im anhaltenden Gespräch. Vielleicht können wir am Anfang beginnen: Wie sind Sie vorgegangen, als Sie anfingen, darüber nachzudenken, wie man diesen historischen Ort wieder für das 21. Jahrhundert relevant machen kann?

1

David Wegener: Die erste Besichtigung des Hauses haben wir auf Einladung von Herrn Hannebauer gemacht. Terraplan und Prinz von Preussen Grundbesitz AG, die das Gebäude von der Stadt Berlin gekauft hatten, waren damals schon dabei, den Gebäudekomplex in Wohnungen umzubauen. Die „Marble Gallery", also die heutige Ausstellungshalle von Fluentum, war da im Grunde ein Rohbau. Den Zustand, wie er mal in den 1930er wie auch in den -50er Jahren zur Zeit der Amerikaner war, haben wir nur auf Fotos gesehen. Es war eine ziemliche Baustellensituation. Beispielsweise waren die ganzen Türlaibungen im großen Saal in der oberen Etage ausgebaut oder eingehaust, die Decke im Erdgeschoss teilweise schon abgenommen, weil man kurz davor stand, einen Aufzug einzubauen. So haben wir das Haus zum ersten Mal gesehen. Und dann haben wir angefangen, nachzudenken: über die Anforderungen dieses Gebäudes, die Galerie, die privaten Räume und die eigentlich recht absurde Situation, dass das hier schon einmal umgenutzt wurde.

Im Wesentlichen sind die Ideen zum Umbau durch Sauerbruch Hutton also auf der Baustelle entstanden. Mich haben von Anfang an zwei Sachen beeindruckt: einmal, dass dieser Verwaltungsbau durch diese relativ piefigen Wohnungen, die da jetzt entstanden sind, in gewisser Weise entweiht wird, weil man innerhalb der Wohnbereiche eigentlich gar nichts mehr von der ursprünglichen Anlage erkennt. Der zweite Punkt war, dass das Gebäude 1935 mit einer Betondachkonstruktion gebaut wurde. Scheinbar wurde also vier

the concrete structure above it was being rebuilt. The question then was whether this should be restored in a historically authentic manner at all. The two ideas came together. The second important point was the idea of placing this wall in the exhibition space.

Matthias Sauerbruch: What impressed me when I first visited the construction site was simply how this material served as a means of expression. It doesn't leave you untouched. You're taken in by the building when you start marveling at this material and, of course, when you know that this was or is a Nazi building, you feel caught.

DW: You also get taken in by the architecture's dramatic presence. You walk up this slightly arched driveway, then there is the courtyard, the sequence of ever-so-slightly ascending trees. Inside, there is this impressive staircase. I always found it peculiar that it ends without a real conclusion. After climbing the stairs, you end up in this big conference room, and you wonder: so, that's it now? However, contemplating the pull of the architecture, the idea came up that maybe you have to break that. So we decided on a wall that would be built right behind the vestibule, thus totally altering the space's rhythm.

MS: Exactly. The part of the ceiling where you can see that the supports are not solid and only covered with marble shells is also important here. It is then dissolved into this kind of theatrical gesture, which it really is. That makes it approachable, workable, and it begins to react, open up—or be opened up—by the material contrast. The inserted wall plays with the building's dramatic presence a bit and delays its onset a bit more. You expect—ta-da!—something great to follow when you enter, but then you are slowed down at the start.

FL: When working on our publication series, it was interesting to see how fragmentary the source material is and how all these specific views then become very coded. Since the building has existed in two political systems, we repeatedly became aware—for example, regarding the visual material that we frequently work with—that everything is always documented from a specific perspective. Your reference, David, to the preservation of historical monuments is also interesting in this respect, because when there are multiple perspectives, the question arises as to what actually forms the "real" basis for historical, architectural, and preservation work.

DW: According to received opinion, whatever forms the original version is what should be restored—as long as some of it still exists. And only when it has already been remodeled do you discuss whether it could be done differently. However, the person in charge of the Lower Monument Authority in Zehlendorf is a very interesting and educated man, who soon warmed to our ideas. The building permit originally required all the lights from the Nazi period to be mounted. Some of them had not even been reinstalled by the Americans, so he agreed to let us refurbish them and keep them in storage, where they have to remain available in case one later wants

Jahre vor dem Krieg die Bombensicherheit schon mitgedacht. So habe ich das interpretiert. Das ist in gewisser Weise auch erschreckend. Als wir den Raum zum ersten Mal besichtigten, haben wir unter der bereits halb abmontierten Abhanghangdecke diese Betonrippendecke gesehen. Ich fand beeindruckend, wie das Haus eine Materialität aus einem anderen Jahrhundert vorgibt, aber dahinter eigentlich diese hochmoderne Konstruktion steht.

Wir starteten in dem Wissen, dass die Denkmalbehörde erstmal ihre Grundannahme verfolgt, alles wieder genauso herzurichten, wie es ursprünglich war. Nur wenn Dinge nach der Erstfassung schon überformt wurden, erklären sie sich bereit, diesen Zustand zu erhalten oder erlauben, dass sozusagen eine dritte Fassung, eine neue Variante eingesetzt wird. Nun gab es da also diese Decke, die zwar original, aber schon halb zerstört war. So entstand langsam die Idee, die Abhangdecke vollständig abzunehmen. Die Decke in der Rotunde war bereits entfernt worden, da die Betonkonstruktion darüber neu hergestellt wurde. Da stellte sich die Frage, ob man diese jetzt überhaupt historisch korrekt wiederherstellen sollte. Die beiden Ideen kamen zusammen. Der zweite wichtige Punkt war die Idee, diese Wand in den Ausstellungsraum zu stellen.

Matthias Sauerbruch: Was mich bei der Erstbesichtigung auf der Baustelle beeindruckte, war die Ausdruckskraft des Materials. Das lässt einen nicht unberührt. Und natürlich, wenn man weiß, das war, beziehungsweise ist ein NS-Bau, fühlt man sich auch ertappt. Man geht dem Gebäude auf den Leim, wenn man erstmal dieses Material so bestaunt.

DW: Man geht natürlich auch der Inszenierung auf den Leim. Du gehst die leicht gewölbte Auffahrt hoch, hast den Vorplatz, die Sequenz von immer leicht ansteigenden Bäumen. Innen folgt dann diese beeindruckende Treppenanlage. Hier fand ich immer witzig, dass dieser Aufgang ohne wirklichen Schlusspunkt endet. Wenn man die Treppen hochgeht, kommt man letztendlich in diesen großen Konferenzraum und fragt sich: Das war's jetzt? Aber in der Wahrnehmung dieser Auffahrtsbewegung ist unsere Idee entstanden, dass man das brechen muss. Also entschieden wir uns für eine Wand, die direkt hinter den Windfang eingebaut wird und damit den Rhythmus total verändert.

MS: Wichtig ist da zum Beispiel auch die Stelle an der Decke, an der man erkennt, dass diese Stützen nur mit Marmorschalen verkleidet und aber eben nicht massiv sind. Das löst sich dann in so eine theatralische Geste auf, die es ja auch ist. Durch diesen Materialkontrast wird es nahbar, verarbeitbar und es fängt an, zu reagieren, öffnet sich oder wird geöffnet. Die eingesetzte Wand spielt mit der vorhandenen Inszenierung und zögert es noch ein bisschen heraus. Man erwartet, tata, dass beim Eintritt irgendetwas Tolles kommt, aber man wird erstmal gebremst.

FL: In der Arbeit an unserer Publikationsreihe war es immer interessant, wie fragmentarisch die Quellenlage ist und wie all diese bestimmten Blicke dann sehr codiert sind. Da das Gebäude in zwei politischen Systemen existiert hat, wurde uns immer wieder bewusst – beispielsweise beim

to restore them to their original condition. There were also huge plaster rosettes on the ceilings that didn't look as large in the room as they actually were when they were taken down and laid on the floor. Those, too, were originally required to be reinstalled. Here, we were able to agree on having a 3D measurement taken and storing a small sample of the rosette for the future. After that we were permitted to dispose of the rest.

MS: This is also due to the fact that we are talking about toxic material here, of course. Having the Luftgaukommando reconstructed would amount to more than just preserving an architectural monument. This is probably one of the reasons why there was a heightened sensitivity and willingness to accommodate us.

FL: You just mentioned that the Luftgaukommando's construction employed the most modern technologies of the time while still maintaining a neoclassical appearance, a fact that you made visible through purposeful interventions, such as the removed ceiling cladding. An architectural firm like Sauerbruch Hutton operates according to the maxims of Modernism, so it has a critical understanding of forms and their social function. This is particularly evident in your projects with preexisting architecture, where you respond to the architecture's dramaturgy and visual idiosyncrasies. What responsibility does the architect bear when confronted with an existing building that, as in the case of buildings from the Nazi era, is surrounded by a complex moral discussion? In Berlin in particular, many Nazi buildings were constructed, but only a few today are considered to be architectural monuments. Many of these buildings have disappeared into everyday life. In this case, however, with the Luftgaukommando and Fluentum—our entire research project— its existence as Nazi architecture is strongly addressed. It is still an accessible place, semipublic, and this raises the question that also concerns us in our publication series: What kind of responsibility does one have, especially when considering the urban and historical context?

MS: We have a whole series of projects in which we respond to already existing contexts. One project that falls into this category is the fire and police station for the government district in Berlin, which was actually a fragment of a building: a bit of a front building and a bit of a side wing from the former main customs office. The Zollpackhof, that small place where you can eat sausages and schnitzel in the summer nowadays, is named that way because that was its actual former function. Right next to it was a huge railroad track, and on both sides of it, where the Ministry of the Interior is today, stood a large warehouse and the administrative customs building. During the Nazi era, however, Jewish citizens were transported to concentration camps from this location. So in a way, it is also an evil place. The building was bombed during the war. All that remained was a corner that stood suspended between the trees for years. Originally, the building had extended all the way to the street, to Alt-Moabit, but all that was gone besides this little piece. So we decided on something quite pragmatic. We took advantage of the architecture we found, but made it clear,

Bildmaterial, mit dem wir viel arbeiten –, dass alles immer aus einer spezifischen Perspektive aufgenommen ist. Ihr Verweis auf den Denkmalschutz ist in der Hinsicht auch spannend, denn wenn es mehrere Blickwinkel gibt, wird fraglich, was denn eigentlich die „wirkliche" Grundlage für historisches, architektonisches und denkmalpflegerisches Arbeiten ist.

DW: Die Schulmeinung besagt erstmal, dass das, was die Originalfassung bildet, auch wiederherzustellen sei – solange noch etwas davon vorhanden ist. Und erst wenn es schon überformt wurde, beginnt man zu diskutieren, ob man es auch anders machen könnte.

Aber der Verantwortliche der Unteren Denkmalbehörde in Zehlendorf ist ein sehr interessanter und gebildeter Mann, der sich schnell mit unseren Ideen anfreunden konnte. Die ursprüngliche Auflage der Baugenehmigung war, dass alle Leuchten aus der NS-Zeit wieder montiert werden müssen. Die waren aber teilweise bei den Amerikanern schon nicht mehr montiert, also hat er sich bereit erklärt, dass wir sie aufarbeiten und einlagern dürfen. Die Lampen müssen für den Fall, dass man den Originalzustand wieder herstellen möchte, zur Verfügung stehen. An den Decken gab es außerdem riesige Gipsrosetten, die in der Raumhöhe nicht so groß wirkten, wie sie dann tatsächlich waren, als sie abgenommen wurden und auf dem Fußboden lagen. Auch die hätten ursprünglich wieder montiert werden sollen. Da konnten wir uns darauf einigen, dass wir ein 3D-Aufmaß produzieren lassen und ein kleines Tortenstück von der Rosette für die Zukunft einlagern. Dann durften wir den Rest entsorgen.

MS: Natürlich ist das auch der Tatsache geschuldet, dass wir hier von toxischem Material sprechen. Wenn man das Luftgaukommando wieder rekonstruieren lassen würde, wäre das mehr als bloß die Bewahrung eines Baudenkmals. Wahrscheinlich war auch deswegen eine erhöhte Sensibilität und Bereitschaft da, uns entgegenzukommen.

FL: Sie haben gerade schon angesprochen, dass das Luftgaukommando eigentlich unter Einsatz modernster Technologien der Zeit gebaut wurde, aber diese neoklassizistische Anmutung trägt, die Sie dann durch gezielte Griffe wieder offengelegt haben, wie am Beispiel der Deckenverkleidung, die abgenommen wurde, deutlich wird. Ein Architekturbüro wie Sauerbruch Hutton agiert nun unter den Maximen der Moderne, hat also ein kritisches Verständnis von Formen und ihrer gesellschaftlichen Funktion. Dies zeigt sich vor allem an Ihren Projekten mit bereits bestehenden Architekturen, in denen Sie auf Dramaturgien und visuelle Eigenheiten reagieren. Welche Verantwortung trägt man als Architekt, wenn man mit einem bestehenden Bau konfrontiert ist, der, wie im Falle eines Gebäudes aus der NS-Zeit, eine große moralische Diskussion mit sich bringt? Gerade in Berlin sind viele NS-Bauten entstanden, von denen heute wenige dezidiert als Architekturdenkmäler deklariert sind. Viele dieser Bauten sind in die Alltäglichkeit verschwunden, aber hier mit dem Luftgaukommando und Fluentum, unserem Rechercheprojekt, wird der Aspekt, dass es sich um eine NS-Architektur handelt, offensiv zum

through the exterior positioning of our addition and the contrasting material choices, that this is something new. It's colorful, shiny, and with rounded corners, whereas the existing building was a Prussian civil service building. Through making it abundantly obvious that it's a new layer, an addition, it signifies that it's a new chapter, if you will. I think that's very important. In Dahlem, you can still find the traces of the removed swastika and the eagle. To describe this layering, pieced-together aspect, we use the image of the palimpsest.

In projects responding to existing architecture, we often actually tried to bring out the building's inherent qualities. In the case of Fluentum, of course, the relationship is somewhat more ambivalent. We didn't want to accentuate the existing architecture's obvious qualities here, but rather react to them, questioning them and enriching them with certain qualms in the process.

DW: It was also fun, in a way, to unmask this disguise. When the idea came up—I don't remember who had it— to literally topple the pedestals that the busts of Hitler and Göring had rested on, everyone was on fire right away of course, because one could simultaneously create a means for reusing these components and perhaps express one's opinion on ideology a little. I did feel there was a responsibility when working on the building, but I didn't feel overly biased, precisely because it had already been remodeled so many times. For me, the fact that the Americans had actually continued to use the place essentially unchanged also played a role. I found that very interesting.

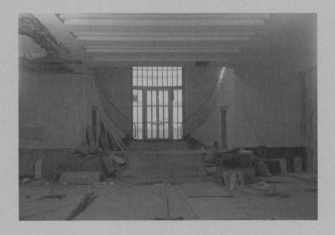

FL: Our attempts to determine what architect Eckhart Muthesius changed about the building for the Americans were quickly thwarted because there are no plans of his work. As an architectural firm, however, you can nevertheless perceive these competing voices. One can speculate that Muthesius was already guided by the idea of freeing this building from its ideological baggage.

DW: It was really a very discreet removal, or revision, of the symbols, so to speak. He didn't do much else. It went as far as reworking the swastika inlays in the hall doors with a new layer of veneer. The Americans didn't really change anything about the basic structure after that, but continued just the

Thema gemacht. Es ist immer noch ein zugänglicher Ort, semi-öffentlich, und daran hängt die Frage, die uns in der Publikation beschäftigt: Welch eine Aufgabe hat man in Bezug auf die Stadt, in Bezug auf diese spezifische (zeit-) historische Situation?

MS: Wir haben eine ganze Reihe von Projekten, in denen wir auf bereits bestehende Kontexte eingehen. Ein Projekt, das in diese Kategorie fällt, ist die Feuerwache im Berliner Regierungsviertel. Das ist eigentlich ein Gebäudefragment, ein Stückchen Vorderhaus und ein Stückchen Seitenflügel vom ehemaligen Hauptzollamt. Der Zollpackhof, also das Häuschen, in dem man heutzutage im Sommer Würstchen und Schnitzel essen kann, heißt so, weil es tatsächlich einmal einer war. Direkt daneben befand sich eine riesige Gleisanlage und auf der einen wie auf der anderen Seite, wo heute das Innenministerium ist, war ein großes Lagerhaus sowie das Verwaltungsgebäude vom Zoll. Es wurden aber in der NS-Zeit von dieser Stelle aus auch jüdische Mitbürger*innen in Konzentrationslager transportiert. Das heißt also, dass das irgendwie auch ein „böser" Ort ist. Im Krieg ist das Gebäude zerbombt worden. Stehengeblieben ist allein ein Winkel, der jahrelang zwischen den Bäumen abgehängt stand. Ursprünglich erstreckte sich das Gebäude bis an die Straße, bis an Alt-Moabit, und das war bis auf dieses Stückchen alles weg. In diesem Fall haben wir uns für etwas ganz Pragmatisches entschieden. Wir haben uns die Architektur, die wir vorfanden, zunutze gemacht und aber durch die Außenposition unseres Anbaus sowie der Materialkontraste deutlich gemacht, dass es sich hier um etwas Neues handelt. Es ist farbig, glänzend, mit gerundeten Ecken, während das Bestandsgebäude ein preußisches Zivilgebäude ist. Wichtig war für uns also dieses Super-Klar-Machen, dass es eine neue Schicht ist, eine Ergänzung, dass es sozusagen ein neues Kapitel ist, wenn man so möchte. In Dahlem findet man die Anbringungsspuren des abgeschlagenen Hakenkreuzes und des Adlers ja noch vor. Und für dieses Geschichtete, oder Aneinandergefügte, verwenden wir das Bild des Palimpsests.

Bei Projekten, in denen wir auf bestehende Architektur reagieren, ist es oft so, dass wir eigentlich versucht haben, die Qualitäten herauszuholen, die drinstecken. Im Fall von Fluentum gibt es natürlich ein etwas distanziertes Verhältnis. Wir wollten hier nicht die offensichtlichen Qualitäten der vorgefundenen Architektur herausarbeiten, sondern auf diese reagieren und dabei eher hinterfragen und durch gewisse Zweifel bereichern.

DW: Es hat auch einen gewissen Spaß gemacht, die Demaskierung dieser Verkleidung zu betreiben. Als die Idee aufkam – von der ich auch nicht mehr weiß, von wem sie war – die Podeste, auf denen die Büsten von Hitler und Göring platziert waren, im wahrsten Sinne des Wortes zu stürzen, waren natürlich gleich alle Feuer und Flamme, weil es so naheliegend ist, gleichzeitig eine Wiederverwendung dieser Bauteile zu schaffen und vielleicht doch ein bisschen seine Meinung zur Ideologie zu äußern. Bei der Arbeit empfand ich schon eine Verantwortung, fühlte mich aber auch nicht übermäßig befangen, gerade weil das Haus schon so oft überformt worden war. Es hat für mich eine Rolle gespielt,

Matthias Sauerbruch and David Wegener

same. That's an interesting point where you ask yourself, is architecture inherently ideological?

FL: What ideas and challenges influenced the transformation of the location into an exhibition space? The place was not originally designed with this function in mind.

MS: First of all, we installed the infrastructure necessary for the appropriate cables, lighting options, et cetera to be available. Since we knew that the collection consists primarily of video art, we chiefly implemented means to black out the space. When the exhibitions began, I was very pleasantly surprised by the narrative dimension that suddenly opened up.

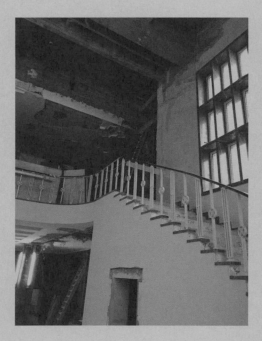

DW: The existing infrastructure definitely played a big role. The moment the ceiling was exposed, which also created the possibility of hanging things anywhere on the first floor, we started thinking about the technology. The rails for the tech equipment were intended to be as elegant as possible, pretending to not even be there. It became clear relatively quickly that the lighting positions could not be solved perfectly, particularly due to the problematic windows in the staircase. We briefly discussed with the Monument Authority whether there could be another solution, but that would have meant a very costly reconstruction, which would have also changed a lot of the shapes of the window elements.

FL: It's also important not to forget what space you're in here. Almost entirely darkening everything would also conceal the architecture. That kind of secrecy is not necessarily a good thing, especially in a building with a history like this

dass die Amerikaner das Haus eigentlich im Wesentlichen ohne Veränderung weiter benutzt hatten, was ich sehr interessant fand.

FL: Unsere Versuche, festzustellen, was der Architekt Eckhart Muthesius für die Amerikaner am Gebäude verändert hat, ist schnell daran gescheitert, dass es keine Pläne der Arbeiten gibt. Als Architekturbüro nimmt man aber dennoch diese konkurrierenden Stimmen wahr. Man kann spekulieren, dass Muthesius bereits von der Idee angeleitet war, dieses Gebäude von seinem ideologischen Ballast zu befreien.

DW: Das war ja sozusagen wirklich eine sehr dezente Entfernung oder Überarbeitung der Symbole. Viel hat er sonst nicht gemacht. Das ging so weit, dass die Hakenkreuz-Intarsien in den Saaltüren nur mit einer neuen Furnierschicht überarbeitet wurden. Die Amerikaner haben danach eigentlich nichts an der Grundstruktur geändert, sondern genauso weitergemacht. Das ist ein interessanter Punkt, wenn man sich fragt: Kann eine Architektur überhaupt ideologisch sein?

FL: Welche Ideen und Herausforderungen beeinflussten die Umwandlung des Raums in einen Ausstellungsraum? Ursprünglich ist der Ort ja nicht mit dieser Funktion im Hinterkopf entworfen worden.

MS: Erstmal haben wir die Infrastruktur eingebaut, sodass die entsprechenden Kabel, Beleuchtungsmöglichkeiten und Weiteres zur Verfügung stehen. Da wir wussten, dass die Sammlung in erster Linie aus Videokunst besteht, haben wir uns primär um Verdunklungsmöglichkeiten gekümmert. Als dann der Ausstellungsbetrieb begonnen hat, war ich von der narrativen Dimension, die sich dann plötzlich eröffnet, sehr angenehm überrascht.

DW: Die bereits bestehende Infrastruktur hat auf jeden Fall eine große Rolle gespielt. In dem Moment, als die Decke freigelegt wurde und dadurch auch die Möglichkeit entstand, an jeder Stelle im Erdgeschoss etwas aufzuhängen, haben wir angefangen, die Technik mitzudenken. Die Technikschienen, die als *grid* angebracht sind, sollten so elegant wie möglich sein und so tun, als wären sie gar nicht da. Dass die Lichtpositionen nicht total optimal gelöst werden können, war relativ schnell klar, da vor allem die Fenster im Treppenaufgang problematisch waren. Mit dem Denkmalschutz wurde kurz diskutiert, ob es auch eine andere Lösung geben könnte, aber das wäre ein sehr aufwändiger Umbau gewesen, der auch viel an der Form der Fensterelemente geändert hätte.

FL: Es ist ja auch wichtig, dass man nicht vergisst, in welchem Raum man sich hier eigentlich befindet. Wenn man alles nahezu vollständig abdunkelt, würde dadurch auch die Architektur versteckt. Diese Heimlichtuerei ist gerade in einem Bau mit so einer Geschichte nichts Gutes. Gleiches

one. The same applies to the redesign of what already existed: if one has the possibility, for example, to render an insertion or the restoration elements visible, then the intervention should be made perceptible. It's a more honest form.

DW: To be honest, I also find it interesting that the artists are now forced to deal with this space. That might not make them happy at times, and they'll have to approach it with a certain amount of fear at first, but at least something is happening. I think that's really great.

1 These photographs were made by Sauerbruch Hutton during their first visits to the site.

gilt für die Umgestaltung von bereits Bestehendem: Wenn man die Möglichkeit hat, zum Beispiel auch einen Einschub oder restaurative Elemente kenntlich zu machen, dann sollte dieser Eingriff auch wahrnehmbar sein. Das ist die ehrlichere Form.

DW: Ich finde ehrlich gesagt auch interessant, dass die Künstler*innen jetzt gezwungen sind, sich mit diesem Raum auseinanderzusetzen. Das finden die manchmal vielleicht nicht ganz glücklich und müssen sich dann auch erstmal mit einer gewissen Angst an den Raum herantasten, aber zumindest passiert etwas, das finde ich ganz toll.

1 Die abgebildeten Fotografien sind während der ersten Standortbesichtigungen durch Sauerbruch Hutton entstanden.

Matthias Sauerbruch founded the office Sauerbruch Hutton together with Louisa Hutton in 1989. He has taught at the AA, London, and has held professorships at the TU Berlin, the Academy of Fine Arts Stuttgart, the University of Virginia in Charlottesville, the Harvard Graduate School of Design, and the University of the Arts in Berlin. He is a founding member of the German Sustainable Building Council, an Honorary Fellow of the American Institute of Architects, and a member of the Architecture Section of the Akademie der Künste, Berlin.

After studying architecture, David Wegener worked for KPMG Consulting and thyssenkrupp AG, among others. Since 2001, he has been a project manager at Sauerbruch Hutton, where he has supervised major projects mainly in the fields of culture, office buildings, and interior design. He regularly gives guest lectures at universities and symposia. He has been an associate and member of the Management Board since 2010. He has been a partner since 2020.

Introduction
Anja Kirschner
Amalgamation, Irreversibility, Mutation

Details are not known for sparing one from the vast stimuli they produce. Once put into the world, they reliably irritate, offend, or overwhelm. In line with the etymological origin of the word (from the French *détailler*, meaning to break down into individual parts), they sabotage our attempts to comprehend a larger whole. Precisely for this reason, a polyphony of details can be a source for a genuine openness of interpretation, which elides any predetermined direction and instead always takes new turns (Daniel Arasse).

In "Amalgamation, Irreversibility, Mutation," which consists of a text and a series of photographs, artist Anja Kirschner discusses both allegorical and literal shards of twentieth-century history, and the impossibility of adequately describing them—let alone logically reassembling them—in light of their violent genesis. On the occasion of her exhibition *UNICA* at Fluentum in spring 2022, the artist developed a film of the same name, scenes of which were shot on Berlin's Teufelsberg. One of many *Trümmerberge* in Germany, this artificial hill was created after 1945 by amassing rubble from the Second World War; today, it presents itself as a lush forest.

The photographs on the following pages are by-products of *UNICA*'s making, portraying an active historical process that has been washed to the surface and into our field of vision in the form of material details. Although these things were there before, in the photographic frame they resemble foreign bodies, like objects on a set, arranged and staged for a magazine editorial. The formal concentration on these details makes them appear in a different, decidedly somber light, exposing the strange, cryptic quality that lies at the heart of their very existence. The focus in Kirschner's contribution shifts away from Teufelsberg as a monumental entity whose architecture is designed to be forgotten. Instead, Kirschner hones in on the most opaque narratives stored in the historical details, which in their scrappy nature nonetheless carry more information for navigating through the rubble of the past than one is able to grasp at first glance.

Einleitung
Anja Kirschner
Verschmelzung, Unumkehrbarkeit, Mutation

Details sind in der Regel nicht dafür bekannt, das Gegenüber mit Reizen zu verschonen. Einmal in die Welt gesetzt, sind sie ein verlässliches suggestives Mittel, um zu irritieren, anzuecken oder zu überfordern. Im Hinblick auf den etymologischen Ursprung des Worts (franz. *détailler*, in Einzelteile zerlegen) sabotieren sie folglich unser Verständnis von einem fassbaren Ganzen. Gerade deshalb liegt in der Vielstimmigkeit von Details eine genuine Offenheit hinsichtlich ihrer Deutung, die in keine eindeutige Richtung verläuft, sondern immer wieder neue Abzweigungen nehmen kann (Daniel Arasse).

In ihrem künstlerischen Beitrag *Verschmelzung, Unumkehrbarkeit, Mutation*, der sich aus einem Text- und Bildteil zusammensetzt, spricht Anja Kirschner von den allegorischen sowie buchstäblichen Scherben der Geschichte des 20. Jahrhunderts, und von der Unmöglichkeit, diese angesichts ihrer gewalttätigen Entstehung adäquat zu beschreiben, geschweige denn, sie wieder zusammenzufügen. Anlässlich ihrer Einzelausstellung *UNICA* im Frühjahr 2022 bei Fluentum entwickelte die Künstlerin einen gleichnamigen Film, dessen Szenen teilweise auf dem Berliner Teufelsberg gedreht wurden. Als einer von vielen Trümmerbergen Deutschlands versammelt der nach 1945 künstlich angelegte, heute begrünte Hügel tonnenweise Häuserschutt des Zweiten Weltkriegs unter sich.

Die Fotografien, die die folgenden Seiten vollflächig ausfüllen, sind gleichsam ein Teilprodukt von *UNICA* und portraitieren einen sich in Bewegung befindlichen, geschichtlichen Prozess, der uns in Form von materiellen Details an die Oberfläche und ins Sichtfeld gespült wird. Obwohl diese Dinge zuerst da waren, wirken sie im fotografischen Ausschnitt teils wie Fremdkörper in ihrer Umgebung und erinnern an Objekte am Set, die für ein Magazin-Editorial arrangiert und in Szene gesetzt werden. Die formale Konzentration auf die Details lässt sie in einem neuen, hier dezidiert dämmrigen Licht erscheinen, und stellt ihre eigentümlichen, kryptischen Qualitäten heraus, die in ihrem Dasein selbst begründet liegen. Vom Teufelsberg als monumentale Einheit, dessen Architektur auf das Vergessen angelegt ist, verlagert sich der Fokus in Kirschners Beitrag auf die in den historischen Details gespeicherten, höchst opaken Narrative, die in ihrem bruchstückhaften Wesen jedoch mehr Informationen zur Navigation durch den massiven Schutt der Vergangenheit in sich tragen, als man auf den ersten Blick zu erfassen vermag.

Anja Kirschner
Amalgamation, Irreversibility, Mutation

Six kilometers from Fluentum's exhibition space at Clayallee 174 is an artificial hill called Teufelsberg, created in the post-war era between 1946 and 1971. Teufelsberg consists of debris from Berlin's bombed western districts heaped on top of Germania's first building, the Wehrtechnische Fakultät, a colossal military-technical college that was still unfinished at the time of its destruction and too solidly built to demolish entirely. Designed by Albert Speer, the Wehrtechnische Fakultät of the Third Reich's planned capital was deemed exemplary of the spirit of National Socialism as a white supremacist world power. In a speech given at the laying of its foundation stone in 1937, Hitler declared it a monument to "German culture, German knowledge, and German strength."[1]

Teufelsberg is one of many debris mounds, or *Trümmerberge*, that were heaped up in the German cities bombed by the Allied forces during the Second World War, but what makes it exceptional is the Germania ruin at its core. Amassed from twenty-five million cubic meters of debris, or roughly a third of the city's destroyed buildings, and planted over with a million trees, it today has the appearance of a forested hill, rising approximately 120 meters above sea level.[2] The images reproduced on the following pages are video stills gathered by myself and the cinematographer Julian Moser while visiting Teufelsberg in the spring of 2021, in the lead up to making *UNICA*, a video installation commissioned by Fluentum. They show items of debris as they were found on-site, spread across and partially working their way out of the forest floor. Amongst pieces of shattered masonry, bricks, ceramic tiles, and crockery were clumps of matter amalgamated by the extreme heat of the bombings, which had been twisted into bizarre shapes.

How to approach this artifact, a hill made from the materials of a city destroyed by aerial bombardment? The modern notion of the fragment gestures at a totality that could be grasped if all the pieces could be located, joined, and viewed from a transcendent perspective—even if this is always deferred. I pictured an imaginary interactive 3D animation in which I was lifting the materials of Teufelsberg up into the air, sifting the suspended debris from the vegetation, recombining it into houses and their contents kilometers from their original foundations, uncovering the remains of the half-built, half-demolished Wehrtechnische Fakultät, and anchoring them to the spot underneath. I imagined the gaps left in my virtual reconstruction, where amalgamated matter could no longer be separated into its constituent parts, not even on a molecular level. I was confronted by the materiality of these clumps that appeared irreversible.

It's messy attempting one operation by means of another. It's messy, even if, or especially when, those operations are derivative of each other in ways not conclusively defined. And it's messy transposing that into a video, as I eventually did with *UNICA*. But that was the point. Because I do not have adequate language for describing the significance of the clumps. Even "amalgamation" suggests that these were discrete entities to begin with. A mutation then? Mutation not

Anja Kirschner
Verschmelzung, Unumkehrbarkeit, Mutation

Sechs Kilometer entfernt von Fluentums Ausstellungsräumen in der Clayallee 174 liegt der Teufelsberg, ein in der Nachkriegszeit zwischen 1946 und 1971 künstlich angelegter Hügel. Der Teufelsberg besteht aus Trümmern der zerbombten Bezirke im Westen Berlins, die auf dem ersten und zum Zeitpunkt seiner Zerstörung noch unvollendeten Gebäude Germanias, der Wehrtechnischen Fakultät, aufgeschüttet wurden. Das Gebäude hatte sich als zu solide gebaut erwiesen, um es vollständig abzureißen. Die für die geplante Reichshauptstadt von Albert Speer entworfene Wehrtechnische Fakultät galt als beispielhaft für den Geist des Nationalsozialismus als weiße Weltmacht. In einer Rede anlässlich der Grundsteinlegung 1937 erklärte Hitler sie zu einem Wahrzeichen „deutscher Kultur, deutschen Wissens und deutscher Kraft".[1]

Der Teufelsberg ist einer von vielen Trümmerbergen, die in von den Alliierten während des Zweiten Weltkriegs bombardierten deutschen Städten aufgeschüttet wurden. Einzigartig ist er jedoch wegen der Germania-Ruine, die unter ihm begraben liegt. Aufgeschüttet aus 25 Millionen Kubikmetern Schutt, also etwa einem Drittel der zerstörten Gebäude der Stadt, und bepflanzt mit einer Million Bäume, hat er heute das Aussehen eines bewaldeten Hügels, der sich etwa 120 Meter über dem Meeresspiegel erhebt.[2] Die auf den folgenden Seiten abgedruckten Bilder sind Videostills, die von mir und dem Kameramann Julian Moser im Frühjahr 2021 bei den Vorbereitungen zu den Dreharbeiten für die von Fluentum produzierte Videoinstallation *UNICA* auf dem Teufelsberg aufgenommen wurden. Sie zeigen Trümmerteile, wie wir sie vorgefunden haben: über den Waldboden verteilt und sich teilweise aus diesem herausarbeitend. Unter zerbrochenem Mauerwerk, Ziegeln, Keramikfliesen und Geschirr befanden sich zudem Klumpen von zusammengeschmolzener Materie, die durch die extreme Hitze der Bombenexplosionen zu bizarren Gebilden verformt wurden.

Wie soll man sich diesem Artefakt nähern, einem Hügel, der aus den Materialien einer durch Luftangriffe zerstörten Stadt besteht? Das Konzept des Fragments, paradigmatisch für die Moderne, deutet auf eine Totalität hin, die sich erfassen ließe, wenn alle ihre Punkte lokalisiert, zusammengefügt und aus einer transzendenten Perspektive betrachtet werden könnten – auch wenn das Erreichen dieser Situation immer als aufgeschoben gilt. Ich stellte mir eine imaginäre, interaktive 3D-Animation vor, in der ich die Materialien des Teufelsbergs in die Luft hebe, den schwebenden Schutt aus der Vegetation siebe und ihn wieder zu Häusern und deren Inhalt zusammenfüge, kilometerweit von ihren ursprünglichen Fundamenten entfernt, wobei ich die Reste der halb gebauten, halb abgerissenen Wehrtechnischen Fakultät freilege, die sie stattdessen an Ort und Stelle verankert. Ich stellte mir die Lücken vor, die meine virtuelle Rekonstruktion hinterlassen würde, in der die verschmolzene Materie nicht mehr in ihre Bestandteile zerlegt werden könnte, nicht einmal auf molekularer Ebene. Ich wurde mit der Materialität dieser Klumpen konfrontiert, die unumkehrbar zu sein schienen.

just inside the clumps, but proliferating around them until they immerse the shattered masonry, the bricks, ceramic tiles, and crockery, the mound with its porous skin of soil and trees and the specific ruin at its core, and then the building complex erected for the German Luftwaffe at Clayallee 174, any attempt to secure it, to sanitize it, to repackage it into The Metropolitan Gardens. Fluentum. This text.

1 Uwe Gerber, "Wehrtechnische Fakultät und Hochschulstadt," Forst Grunewald, November 17, 2014, http://forst-grunewald.de/?page_id=3802.
2 For a detailed study of Teufelsberg, see Benedict Anderson, *Buried City, Unearthing Teufelsberg: Berlin and its Geography of Forgetting* (London/New York: Routledge, 2017).

Es ist riskant, eine Vorgehensweise mit Hilfe einer anderen zu versuchen. Es ist riskant, selbst wenn, oder gerade dann, wenn diese Vorgänge auf nicht eindeutig definierte Weise voneinander abgeleitet sind. Es ist auch schwierig, dies in ein Video zu übertragen – wie ich es schließlich mit *UNICA* tat. Aber das war der Grund. Denn ich habe keine angemessene Sprache, um die Bedeutung dieser Klumpen zu beschreiben. Selbst der Begriff der Verschmelzung deutet darauf hin, dass es sich ursprünglich um eigenständige Einheiten handelte. Eine Mutation also? Eine Mutation, die nicht nur innerhalb der Klumpen stattfindet, sondern sich um sie herum ausbreitet, in das zerbrochene Mauerwerk, die Ziegel, Keramikfliesen und das Geschirr, den Hügel mit seiner porösen Haut aus Erde und Bäumen und die spezifische Ruine in seinem Kern, und dann den für die deutsche Luftwaffe errichteten Gebäudekomplex in der Clayallee 174 und jeden Versuch, ihn zu sichern, zu säubern, in Metropolitan Gardens zu verpacken. Fluentum. Diesen Text.

1 Uwe Gerber, „Wehrtechnische Fakultät und Hochschulstadt", in: *Forst Grunewald* [17.11.2014], URL: http://forst-grunewald.de/?page_id=3802 (letzter Zugriff: 10.02.2022).
2 Für eine ausführliche Untersuchung des Teufelsberg siehe Benedict Anderson, *Buried City, Unearthing Teufelsberg. Berlin and its Geography of Forgetting*, London, New York 2017.

Anja Kirschner is an artist working with moving images. She is recipient of the Jarman Award (2011), and her works have been widely exhibited internationally, including at Haus der Kulturen der Welt (HKW), Berlin; Secession, Vienna; Benaki Museum, Athens; Palais de Tokyo, Paris; n.b.k., Berlin; Badischer Kunstverein, Karlsruhe; Artists Space, New York; Extra City, Antwerp; Transmission Gallery, Glasgow; the Liverpool Biennial; and Chisenhale Gallery, London.

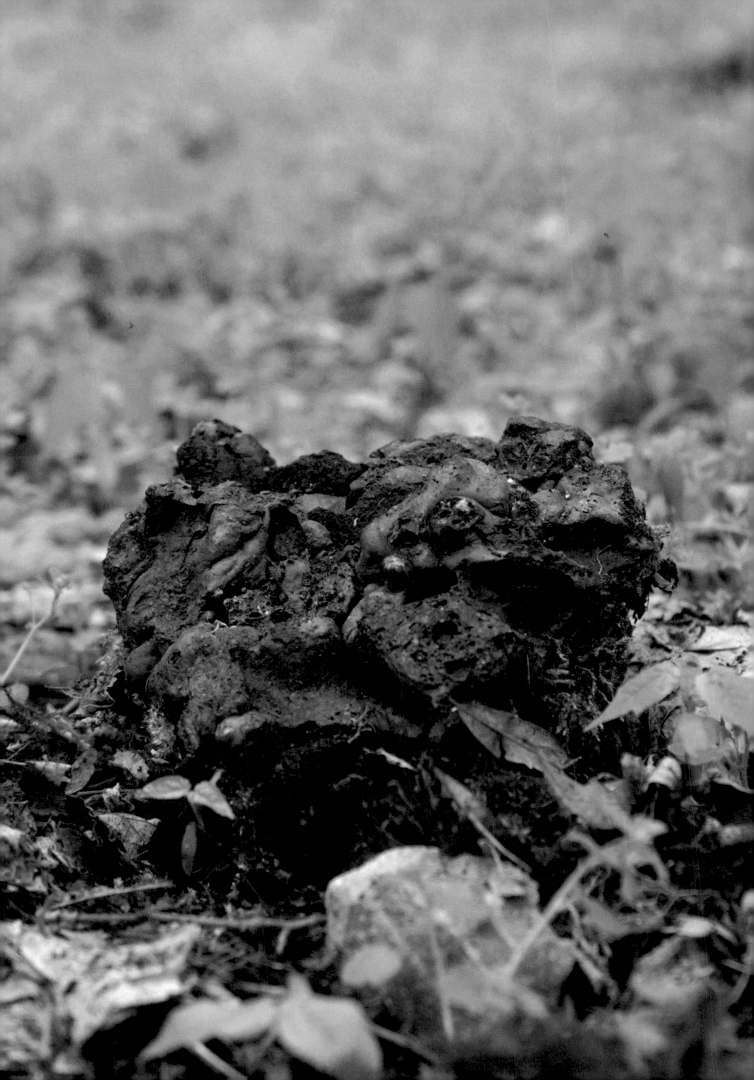

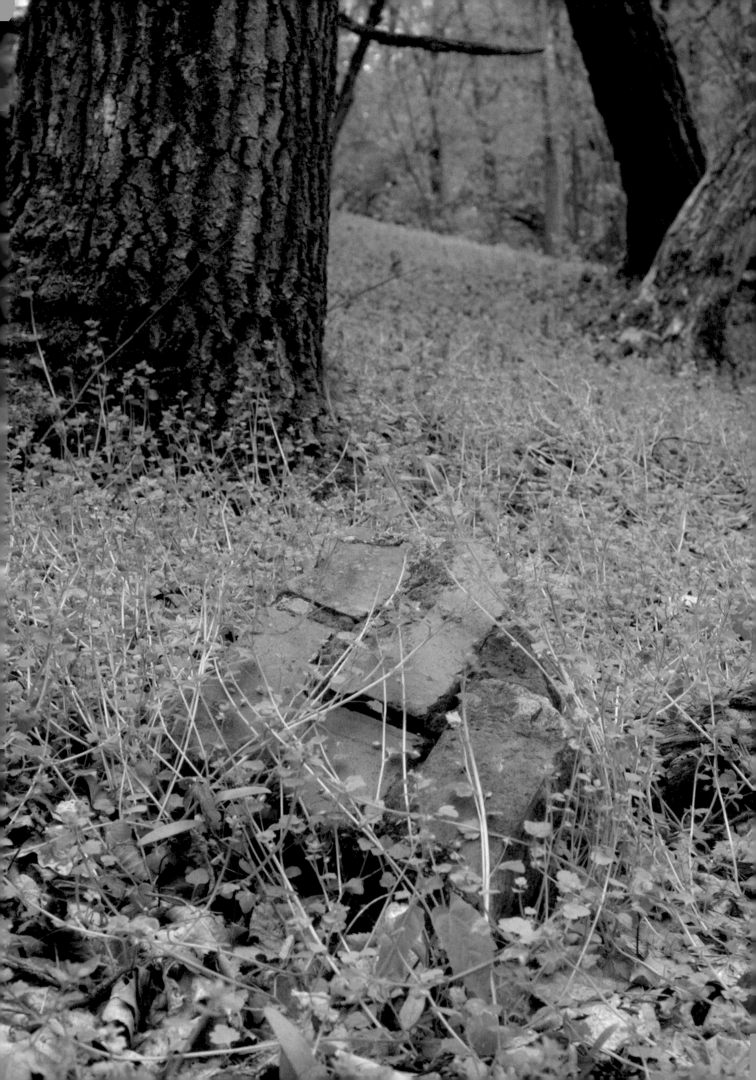

Colophon

In Medias Res #2: Architecture in Motion is the second issue of a multipart publication series, published on the occasion of the program series *In Medias Res: Media, (Still) Moving* at Fluentum, Berlin.

Editors
Dennis Brzek, Junia Thiede

Contributors
Dennis Brzek and Junia Thiede
Julian Irlinger
Petra Kind
Anja Kirschner
Daniel Poller
Matthias Sauerbruch and
David Wegener
Stephan Trüby

Translation
Lisa Contag

Copyediting and Proofreading
Ames Gerould, Andrew Wagner
(English)
Dennis Brzek, Junia Thiede
(German)

Graphic Design
HIT

Cover Typography
Marianne Baum,
Anna Mettbach,
Anne Marie Piguet, 2018
(from Bea Schlingelhoff:
Women Against Hitler)

Cover Image
Daniel Poller, *Kranker Marmor*, 2022

Published and distributed by
Mousse Publishing
Contrappunto s.r.l.
Corso di Porta Romana 63
20122, Milan–Italy

Available through:
Mousse Publishing, Milan
moussepublishing.com

DAP | Distributed Art Publishers,
New York
artbook.com

Les presses du réel, Dijon
lespressesdureel.com

Idea Books, Amsterdam
ideabooks.nl

Antenne Books, London
antennebooks.com

First edition: 2022

Printed in Germany by Druckerei
Rüss, Potsdam

ISBN 978-88-6749-528-3

€ 8 / $ 10

The publisher would like to thank all those who have kindly given their permission for the reproduction of material for this book. Every effort has been made to obtain permission to reproduce the images and texts in this catalogue. However, as is standard editorial policy, the publisher is at the disposal of copyright holders and undertakes to correct any omissions or errors in future editions.

Fluentum

Founder and Director
Markus Hannebauer

Head of Exhibitions and Programs
Junia Thiede

Guest Curator
Dennis Brzek

Head of Production
Jörg Adam

A/V Technology
Moritz Hirsch

Social Media and Communications
Donna Schons

Press
Corinna Wolfien

Fluentum
Clayallee 174
14195 Berlin
www.fluentum.org

The curatorial team and Markus Hannebauer would especially like to thank Dr. Jürgen Lillteicher and Florian Weiß (Allied Museum).